YO-BZZ-813

Aesthetic Journalism

A white, ethereal light floods the whole space. We walk to the other side of the space, listening to our own footsteps. From behind the reception desk, a curly, courteous man hands over the tickets. It's nice, I say, to have such a place where you live. It feels lucky. We exchange a brief glance, and stand there for a second, wondering where to get in for the exhibition…

The space looks almost too big. On the walls, photographs, photocopies, graphic and printed texts. Too soon to understand what it's all about – except the clue of the exhibition title. We get closer. They're stories. Facts, chronicles, charts, drawings, statistics, voices, faces. They're maps, in a sense. The monitors and headphones; the projections floor-to-ceiling; the bench; the cables; the panels. They're all maps.

We're not in a hurry, are we? You whisper, half smiling. No, I say, we're not.

Aesthetic Journalism
How to inform without informing

Alfredo Cramerotti

Intellect Bristol, UK, Chicago, USA

First published in the UK in 2009 by
Intellect, The Mill, Parnall Road, Fishponds, Bristol, BS16 3JG, UK

First published in the USA in 2009 by
Intellect, The University of Chicago Press, 1427 E. 60th Street, Chicago, IL
60637, USA

Copyright © 2009 Intellect Ltd

All rights reserved. No part of this publication may be reproduced, stored
in a retrieval system, or transmitted, in any form or by any means,
electronic, mechanical, photocopying, recording, or otherwise, without
written permission.

A catalogue record for this book is available from the British Library.

Co-published with Künstlerhaus Büchsenhausen

BÜCHS'N'BOOKS
Art and Knowledge Production in Context

Büchs'n'Books – Art and Knowledge Production in Context. Edited by
Andrei Siclodi – Volume 2

Address: Künstlerhaus Büchsenhausen, Weiherburggasse 13/12,
6020 Innsbruck, Austria
Phone: +43 512 278627 / Fax: +43 512 278627-11
Email: office@buchsenhausen.at / Website: http://buchsenhausen.at

Cover designer: Holly Rose
Copy-editor: Heather Owen
Typesetting: Mac Style, Beverley, E. Yorkshire

ISBN 978-1-84150-268-7
 978-3-9502583-2-5

Printed and bound by Gutenberg Press, Malta.

Contents

Foreword

by Sally O'Reilly

We've all pretty much come to the conclusion that art does not thrive in a vacuum. In fact, we are most insistent that art inhabits the social realm, that its use value is not primarily that of luxury goods, but something altogether more dialogical. Art and the everyday have famously elided in a democratic gesture of inclusion: of the artist in society and the viewer in the process of generating meaning. Many practitioners, however, cannot quite shake the romantic ideal of the artist. At times their prescriptive programme for a dialogical relationship between artwork and world divests such liberalism of its potency, reducing it to mere appearances.

Artists, curators and critics are always talking about 'the viewer' – that mysterious single entity that lurks at the back of every practitioner's mind – but this generally constitutes such an abstracted understanding of audience that it barely seems a humanist concern. While the audience seems to be prioritised over authorship, subjectivity placed above authority, this is as illusory as a perspective; the democratic gesture turns out to be a tromp-l'oeil effect. Indeed, it is more likely that this 'viewer' is considered in denatured, formal terms within reception theory or as a singular element within the triage of meaning making, between object, author and interpreter. An audience is seldom discussed as a number of sentient individuals with conflicting experiences, ideologies and prejudices – a tendency that is particularly dangerous for art that wishes to remain relevant in fractured, fractious times.

A similar difficulty arises when the artist takes another person as subject matter. While I agree that art should contest the impositions and ignorance that constrain us in collective society and public life, I do not believe that the artist enjoys total immunity from the ethics of representation. Aesthetic and conceptual impact must be negotiated with some bearing on the moral compass and, in matters of representation of others, irreverence for political correctness and good manners must be tempered with respect. Then again, ribald subjective authorship is no longer considered the enemy of diplomacy or democracy, and neither is objective truth its yardarm. These categories have ceased to stand for a separation between creative cultural practices and the life sciences, between fiction and knowledge. Contemporary artists need not observe the guilt-induced prohibitions of the ethnographer – who no longer feels comfortable with the insinuations of subjectivity nor the cold detachment of objectivity – but they might learn from the impact of these modes within the tradition of art and journalism. Creativity and information are no longer distinct, as Alfredo Cramerotti explains, therefore we must think of how to inform with a light touch, how to yield pleasure while maintaining a political grasp, how to know and to dream at one and the same time.

Sally O'Reilly

Introduction

Art and Journalism: A Perspective Shift of Meaning

by Andrei Siclodi

The second book in the series *Büchs'n'Books – Art and Knowledge Production in Context* approaches the present relation between certain forms of contemporary art and the world of journalism. Alfredo Cramerotti, who wrote the rough draft of this book in 2007–8 as a fellow at the International Fellowship Programme for Visual Arts and Theory in Büchsenhausen, here carries out an analysis of a phenomenon that might be described as 'the journalistic turn in the contemporary visual arts'.

Following the second wave of 'institutional critique' and the re-politicization of the art field that it brought with it, artistic practices since the 1990s have taken on forms that aim at a manifest investigation of mainstream conceptions of reality. In the first decade of the twenty-first century, the mass media was influenced by an increasing aestheticization of the distribution and publication of information. Among other things, the growing commercial pressure on the media as a result of rapidly developing global capitalism led to the trend of news being packaged in entertaining formats, whereby the strict separation between information and opinion has become increasingly blurred, objective investigative reporting has lost more and more ground to a processing of news that tends toward 'infotainment'. Parallel to this, a growing interest can be discerned in the art world in aesthetic strategies that directly resort to the treatment and reprocessing of material and knowledge arrived at through investigative work methods. The results of these methods are then made accessible to the public by using journalistic formats or those similar to journalism. The question as to what reality is and how it can be conveyed and/or represented has become crucially significant for these artistic practices.

In light of this development, it can be observed that the question over the truth of what we see and experience has qualitatively shifted from the field of journalism to that of art. And there is no doubt that with 'art' we mean the visual arts. Because since the 1960s,

> art...has gone through a structural change, similar to that of psychology and ethnology, and no longer has its field of knowledge as a life form or organism but rather like these other fields expands the discursive in the crossroads of other humanist fields of science.[1]

I would like to build on this statement with the claim that the discourse of art has expanded even beyond the traditional sciences into many everyday fields, and in general, it has come to represent a specific form of knowledge production that resonates outside of established expert domains. Art's capacity for a certain form of aesthetic-political

objectivity and progressive criticism of what we call 'reality' are important preconditions – and at the same time also cogent reason – for scrutinizing the relationship between art and journalism. Yet this is not the only reason. As with the media, art also employs images and other evidence of reality – in short, documents – in order to conduct its (visual) discourse on reality. Trust in documents, however, has been deeply shaken for some time now – and it will certainly remain so in the future. There is no exterior, no trustworthy refuge outside of the reality of globalized capitalism, from which we might be able to appraise the evidence that comes from inside the system. As Hito Steyerl has aptly formulated it:

> We have long been, so to speak, embedded in the television, and the grainy images with which we live have settled like a luminescent layer of dust upon the world and become indiscernible from it…Traditionally, documentary was the image of the world: now it is rather the world as image.[2]

Information and opinion increasingly blend into one another; the documentary is blurring; a distinction between actuality and fiction may no longer be accurately made through traditional means: in light of this situation, we are confronted with the question as to whether art might be seen as such a (temporarily?) stabilizing refuge within the system for demanding journalism, where the necessary structures for formulating and articulating social criticism that has, to some extent, become impossible within the mass media. If this is so, what consequences for art and for society will this process bring with it? In this book, Alfredo Cramerotti attempts to formulate some answers to these questions and to provide a comprehensible description of what constitutes the practice of 'aesthetic journalism'.

I would like to thank Alfredo for the fantastic collaboration over the last three years and the very fruitful exchange of ideas during this time. My thanks also go to the team of Intellect Books for their cooperation in co-publishing this book.

Andrei Siclodi

Editor of the series *Büchs'n'Books – Art and Knowledge Production in Context*

May 2009

Notes

1. Slettemeas, Eivind (n.d.), Introduction to Art-as Research, http://www.societyofcontrol.com/research/slette_artasres.htm. Accessed 6 May 2009.
2. Steyerl, Hito (2008), *Die Farbe der Wahrheit – Dokumentarismen im Kunstfeld*, Vienna: Turia + Kant.

Chapter 1

ONE THING Among Many

As I understand it, a title is always a challenge

<div align="right">(Jacques Rancière, The Emancipated Spectator)</div>

***Aesthetic Journalism* might sound a bold statement at first. Instead, I would consider** the title as a proposal for *one* method of talking about something, one of many possible. It relates an idea rather than a story, and brings together various practices and ideas without being 'about' them. There are also personal reasons for this title. In 2003 I was commissioned to create an art piece taking as its inspiration the bridge in Istanbul that connects Asia and Europe. I invited another person to work with me. We travelled, came back and realized a three-minute video worked out of thirteen interviews, focussed on the perception of the bridges (two, actually) by the inhabitants of Istanbul. We exhibited the piece in Berlin. It went well. Upon its good reception, I realized something peculiar about the work. Not necessarily wrong, but interesting from a certain point of view, namely: we set off to realize an artwork; we came back with a journalistic piece.

'The distinction between fiction and nonfiction is false […] There is only narrative.' (Suchan 2004: 309). When dealing with creative practices, to attempt such a separation of genres is useless. Back then, however, we failed to question the nature of our means of production, such as interviews, the hand-held camera, questions edited out and visual illustration of statements. While aware of other elements and making certain choices – the author revealing himself with the last question, for instance, or the visuals being a graphic metaphor of the bridges, etc. – we did not query the investigative choice as a whole, and from which position, if such a thing can be defined, we were speaking. We just did it. That is the beauty of art, one might argue. Evaluations and concerns are for others. Well, what you are about to read here stems from that remote piece of artistic investigation; it was long dormant before reaching this form – a sort of alarm bell in my head. And whenever I can, I try to work on what makes the bell ring. That is not to say I have completed the task; in fact, I am just at the beginning.

> I would like my books to be a kind of tool-box which others can rummage through to find a tool which they can use however they wish in their own area […] I don't write for an audience, I write for users, not readers. (Foucault 1994 [1974]: 523–524)

A book is a form of communication that brings together aesthetics and information; the one you are reading attempts to also question the relationship between the two. Here, the text does not function as a voice for the artworks discussed; it exists in dialogue with artistic positions, media theories, journalistic approaches, theoretical debates and personal ideas throughout.[1] I have adopted a number of (journalistic) devices, such as the text box for in-depth notes, borrowed from the layout of weekly magazines, which

break the surface and provide 'tangents' for reflection. In addition, the progression of the arguments follows the '5W+H' convention; many readers might know that it stands for *Who, What, Where, When, Why + How* (albeit slightly re-shuffled here), criteria that originated with the Greek-Latin rhetoric discipline, still in use. Two more things: first, I discuss direct experience of artworks and artistic positions that I encounter in my profession, and these are determined by the conversations and access I have. This book, then, cannot claim a 'global' perspective (neither would I aim at such a thing, to be honest), but perhaps its structure and approach can help the pursuit of parallel research, and in organizing debate in other contexts. Secondly, the work has been a process of un-making, in the sense of dismantling my previous thoughts about art and journalism, and re-building them differently; a rather long route to (un)learn something (Rogoff 2002) in order to make room for something new, of which I was not aware before. Throughout the research and the writing, I put in conversation seemingly disparate areas of interest and perspectives – which may or may not have been brought close to one another in the past – to discuss or challenge their potential meanings according to a new reading. This, in short, is my take on the book. While all the knowledge herein is a shared effort (and I have probably forgotten someone in the final acknowledgements), the mistakes are all mine. Have a nice journey.

Note

1. My thanks to Emma Cocker and her *Notes on Critical Writing* (2007) for clarifying this point in relation to writing. The text was a response given to Chris Brown from *a-n Magazine*, http://www.a-n.co.uk/interface/article/379627. Accessed 22 April 2009.

Chapter 2

WHAT is Aesthetic Journalism?

The relationship between journalism and art is a difficult territory to chart. What I call aesthetic journalism involves artistic practices in the form of investigation of social, cultural or political circumstances. Its research outcomes take shape in the art context, rather than through media channels. I am aware that 'media' is not a monolithic venture that encompasses every production and circulation of information, and I will clarify this. I use 'media', 'mass media' or 'media news' throughout the book to indicate the currents of mainstream broadcast and printed news, often tied up with multinational and governmental publicity resulting in a sort of (private or public) corporate-led information. I focus here not on the political, social and economical nature of such agglomerates, but rather on the information that is produced, distributed and absorbed via them. In an attempt to construct an alternative to such mainstream apparatuses, art tends to use investigative methods in order to achieve a certain amount of knowledge about a problem, situation, individual or historical narrative. The artist thus absorbs him/herself in professional tasks that occasionally are at odds with art production. Sometimes this artistic practice aims to counter today's media news of flashy headlines and 'parachuted' journalists (those assigned to cover issues, on which they have no possibility of doing research); other times it complements (without contradicting) the media view, providing an extra gaze. Journalism, for its part, has always embodied an internal conflict in relation to the production of information. On the one hand, it implies the eyewitness approach of the reporter and field journalist, mediated (hence the word *media*) despite adopting a non-subjective style in the spirit of a claimed objectivity (Huxford 2001). On the other hand, the use of a precise aesthetics by means of photo, video and graphic display of that information provides a sense of witnessing an unmediated account. Thus, even if rarely acknowledged, the interaction of aesthetics and journalism is a common feature: a widespread cultural artefact, not a special field of practice.

Why aesthetic?

Aesthetics is that process in which we open our sensibility to the diversity of the forms of nature (and manmade environment), and convert them into tangible experience. Taking this as a starting point, my suggestion of a journalism 'being' aesthetic takes into account a concept of aesthetics as something other than a state of contemplation. It is rather the capacity of an art form to put our sensibility in motion, and convert what we feel about nature and the human race into a concrete (visual, oral, bodily) experience. The potential of aesthetics in relation to journalism is based on two considerations: first,

as mentioned above, traditional journalism itself uses a highly developed aesthetic tradition, which in time has gained the mark of objectivity. (In fact, as soon as a language is in use, the user faces aesthetic choices.) Thus, by being ubiquitous and universal, the 'consumer' no longer regards it as aesthetics, and accepts it uncritically. Secondly, the implementation of different aesthetics is a way of questioning the hegemony of the *status quo*. Content is – and stays – important, but it is very hard for an artist to live up to the research capabilities of a standard newspaper or TV station. Therefore, the artist has to play his or her cards by disclosing a universally accepted aesthetics of truth, that is: using another aesthetics, which reveals the former as such. Aesthetic journalism makes it possible to contribute to building (critical) knowledge with the mere use of a new aesthetic 'regime', which has the effect of raising doubts about the truth-value of the traditional regime. Not because one is better than the other (or more efficient), but because the appearance of both brings focus to the aesthetics itself, this way denouncing the claim that the system of representation is the same as what it represents (that journalistic representation is the same as the facts represented).

Truth in reporting is a myth: except for a direct involvement in the events of life, only degrees of approximation are possible, those being more or less reliable according to the position of the author, prejudices and obligation towards employers. Only in fields such as law, science and media can one still encounter the presumption of an unbiased representation of facts based on documentation. The artist who uses the tools of investigative journalism in their work adopts techniques like archive and field research, interviewing, surveys; they also employ specific narrative and display formats such as documentary style, graphic visualization, text-based and photo reportage. Ideally, their work offers a grasp on actuality relying on the viewer's sensibility, therefore helping to develop the skills to ask proper questions; the journalistic approach of the artist is geared more towards the 'effect to be produced' rather than the 'fact to be understood' (Rancière 2006b: 158, Demos 2008: 6). One might argue that this very 'artistic' information is also 'consumed' as an aesthetic product within the art world, but such major questions cannot be confined to the art circuit. We no longer consider artists as specialized craftspeople: to produce sense socially and politically one has to abandon the notion of artisanship in favour of innumerable forms of expression, which include film festivals, newspapers, television, internet, radio and magazines. Also, it has to avoid a certain 'spectacularization' of violence and suffering, which may result in an even worse outcome than embedded journalism. There are ways to avoid this and yet still employ fiction as a subversive but meaningful and effective agent of reality, which is precisely one of the aims of this book.

Why journalism?

Journalism is intended to be a service in the interest of the highest number of people possible, not an opportunity to influence decisions and gain power. It defines what is

perceived as 'common', and constructs the boundaries of normalcy for both representation and reality. Journalism as a coded, professional practice establishes a cultural and social order: we read the conventions of representation as though they were reality itself (Williams and Delli Carpini 2000). We accept the journalistic attitude as the bearer of linguistic and visual documents of the reality, because it relates occurrences (on a global scale) to a pattern immediately understandable to our mind frame. The journalistic method is the principal instrument to read the world; it provides a certain security, by establishing an order for the things 'out there', and by constructing a universal form of communication, as such:

> People obtain knowledge of the world outside their immediate experience largely from mass media, where journalistic content predominates. Journalistic ways of depicting reality, journalists' models and modus operandi also influence other social institutions: politics, market actors, educational institutions and so forth. (Ekström 2002: 259)[1]

The power of journalism derives from its alleged capacity to contain the entire world in familiar narrative forms, those recurring in the daily routine of news (Schudson 1995). Thus, the increasing presence of the journalistic method in contemporary art (and many other fields) does not come as a surprise: journalism is the interface we use to understand how things work and affect us, and it forms the base for public knowledge in science, politics and many other fields.[2] In their *Phenomenology of Journalism,* Joseph Bensman and Robert Lilienfeld (1969: 107) indicate that the journalistic attitude is applied not only to information, and not exclusively by journalists, but also in a number of areas outside the journalistic field. For example, scientific knowledge relies on 'visualization' to be accepted; politics makes use of daily news to build its credibility and so on.

Starting from the nineteenth century, news (as we know it) became a system to validate the world around us (Wall 2005); we need the journalistic mediation since we are no longer able to unravel things in any other way, due to the amount of communication processes and relations in which we are embedded. The professional figure of the journalist is necessary to deal with an increasingly complex civilization, which includes the separation of roles and a huge number of processes in administration, science, culture and technology; it mediates these fields to the majority of the population, who have no direct experience of all the multifaceted aspects of society. The definition of aesthetic journalism does not distance itself much from the notion of investigative journalism,[3] given that objectivity is not a measurable feature. For instance, journalistic reportage is intended to produce a deeper understanding of current news events, by means of background analysis, field observation and personal accounts, going further beyond prime-time news reports. Supposedly, investigative journalists travel to the scene of events (or take up a specific subject), gather information and report on the facts and actions of individuals, businesses, crime organizations and government agencies. To

obtain this information for their reports, journalists cultivate the confidentiality of their sources: people directly involved or familiar with the topic investigated. The result of the investigation takes the form of reportage: a term thus signifying a 'witness' genre of journalism, researched and observed first-hand and distributed through the media. The activity of presenting information often blends documentary style, physical or psychological perception and evidence of various natures: a non-fiction cultural production. For an author, to reveal oneself through the work would mean to take a step forward and disclose one's presence, manipulation and influence on the viewer's perception, at the cost of spoiling the entire work by flagging up a warning sign for the spectator not to trust the author's gaze. Yet, a news photograph showing a subject staring directly into the camera is considered non-professional (Becker 2004): how did we end up with such an impersonal (and quite absurd) approach?

The crisis of traditional journalism

By the middle of nineteenth century the idea of the 'average man' in the public eye was firmly grasped, and daily papers commonly presented simple question-and-answer features, usually connected with crime stories. Newspaper and press began to report on social investigations and tribunal decisions, ballots results and average wages, often including interviews and statistical information, like in the case of Henry Mayhew's articles on London poor between 1849 and 1850 in the *Morning Chronicle* (Winston 1995: 133). In the United States media mogul Joseph Pulitzer advanced an idea of journalism intended as a service, with newspapers conceived as public institutions with a duty to improve society. Journalism (and documentary making) borrowed the techniques of investigation and evidence-gathering proper to the legal system, and placed them in the open public realm. Since the emergence of bourgeois society and the raise of modern democracy, journalistic and documentary-based practices have been accepted as a radical form of criticism and truth-telling, without questioning the aspects of power and authority brought in with images and texts. To a certain extent, journalism has been (and still is) considered a body guarantor of public assets, a 'more or less cohesive institution, consisting of distinctive values, practices and relations' (Ekström 2002: 269). In the text just mentioned the author also provides a description of the modalities of media journalistic practice:

During a heat wave in New York in 1883, reporters of *The World* (the newspaper owned by Joseph Pulitzer) wrote stories about the miserable living conditions of immigrants and the toll the heat took on children, laying the foundations of what we know today as investigative journalism.

Journalism makes a point rather than tests hypothesis. In all the reportages we studied, the team of reporters decided early on what they wanted the story to say and then set about gathering evidence to support that message. The journalist searches selectively and focuses on statements that support the point s/he is trying to make. The stories often include several people's testimony in support of the point but exclude others whose statements might blur the issue or raise doubts. The point to be made largely decides the further course of their work. It guides not only the choice of people to interview but also the nature of the questions asked [...] Investigative journalism is a form of story-telling. Coherence is produced when facts are inserted into a narrative that has a structure that is familiar to the viewer. When facts are embedded in a coherent narration that appears to be real and authentic, they become plausible and convincing. (Ekström 2002: 273)

Journalism acts between two poles: on one side, politically correct, or even the 'optically correct' language (Virilio 2007), used as a standard form of communication by respected broadcasters and newspapers. This 'serious' attitude might actually swap an actual episode (and its effectiveness) for its symbolic reading; that is, taking for real what is only a way of telling things (Žižek 2003–4). On the other side, a whole branch of the news industry, popular and stimulating for the audience, takes advantage of the influence and authority of journalism without taking on board the responsibility that we think is implied by that profession, something that David Foster Wallace points out extremely well in his essay 'Host' (2005). In the US and elsewhere press tabloids and radio talk shows, to name the evident cases, use the long tail of journalism respectability to present truth in a very problematic manner. Far from making the representational process more transparent, in this case the whole approach is disguised as objectivity; the personal, collective or institutional agenda behind it remains undeclared. It becomes increasingly frustrating, for the average viewer or listener, to understand which sources to grant credibility, and how to distinguish between information and manipulation. It is now rare to experience the verification, disclaiming of or apology for mistaken or misleading news given the day, week or month before. The audience no longer perceives this distinction, considering everything as either reliable or manipulated, devaluing the authority of any information source. This is the reason, argues Wallace, for the spread of the so-called meta-media, or the explanatory industry: media watchers, experts and critics, commentary programmes, articles on the interpretation of other articles and so forth. These become the self-generative elements of information of the journalistic channel, and do not represent, strictly speaking, a response to outside occurrences (Winston 1995). But we know, as Walter Benjamin, Michel Foucault and others expose in their writings, that to explain means also to influence (Chapter 5); to apply, over a supposed precise piece of information, the opinion of the moderator, sometimes spared by the standard of responsibility.

In the last twenty years or so media companies – either public or private – progressively downsized the resources dedicated to investigative journalism. 'Economically pressed news organisations often prefer to provide cameras (but little training) to willing locals rather than fly professionals out to some scene of conflict' (Stallabrass 2008: 8). Reporters are pressured to shoot everything digitally for print, TV, radio and online demand, and to mix stills with video and sound (like interview fragments, bits of environmental recordings, voice-over comments) in order to provide that 'multimediality' which is the current trade value in the information industry.[4] Journalists in the pressroom are asked to use different and varyingly reliable sources, but in the end – due to budget and time pressure – TV channels and papers tend to duplicate what is provided by press agencies, which in turn distribute what is handed down by public or corporate offices and PR agencies. What is disappearing, along with the facts, is the fact-check: as soon as it is launched, debates can occur, with little or no reference to the original context. The responsibility for the story is erased and – for the audience – verification is substituted for a sense of omniscience (Colombo 2006: 68). Here, focusing on the effects (the commentary, the technique) diverts attention from the cause (the facts) and accountability (the bearer). All this may depend on the change of production and distribution of information with the advent of the web. After the internet boom of the 1990s, and thanks to the technology available, a participatory tendency in journalism has made its way into mainstream media. Both BBC and Al-Jazeera English broadcasters, for instance, provide space for 'citizen journalism' formats, and many regional television and radio stations rely on audience participation for the daily schedule. This includes 'have your say' features, talk shows, studio calls, emails and phone messaging. It is both an important social achievement and the further entanglement of reality check in a net of infinite possibilities. The production of information is now fragmented into thousands of pieces that paradoxically generate a homogenization in the response: too many sources mean no reliable source at all. On 13 April 2005 Rupert Murdoch summarized this change in the course of a speech at the American Society of Newspaper Editors:

> What is happening, in short, is a revolution in the way young people access information. They don't want to depend on a figure similar to a divinity who tells them what is important. They want a point of view on facts, not just what happened, but why it happened. They want new stories to speak to them directly, something that relates to their lives. They want to be able to use that information in a broader community, they want to discuss, ask questions and meet other people who hold the same or opposite views of the world. (Murdoch 2005)

The main issue therefore is no longer objectivity, once the first commandment for every professional journalist, but rather the autonomy and responsibility of the journalist. The effort to tell *one* truth, the only possible truth from an individual point of view, is not a

measurable effort, since it relies both on the sources and the author's interests. A more appropriate standard would be fairness and exactness: taking sides on an issue as long as the position is clear, and a fair chance to reply is given. In theory, the journalist – as witness of history – is required to check facts but to be subjective in the interpretation of things, denouncing fallibility in the pursuit of truth. In practice, though, news has become news-making, an object of negotiation between multiple terms: the source (which one to draw upon, under what circumstances); the journalist profession (what to say, how and when); the interest of employers (or those commissioning the piece); the power (over the subject of the report and over the audience); the public (how the reader's profile influences the journalist and his or her choices). Being in one place and witnessing something (the traditional idea of the reporter) changed into being in many places at the same time and commenting on what happens somewhere else. The pressroom is connected in real-time with online news agencies and services, continuously scanned and monitored, and with a number of correspondents in different locations who broadcast live from their video camera (or mobile phone camera). The report is usually mediated by the experts mentioned earlier, who comment on the live feed of images, and by digital editors that mix, overlap, crop and insert graphics and running texts. This 'globalization' of news gives the emotion of total co-temporality, but tends to destroy context. We do not know anymore in which situation something takes place, since the context is provided not by external (and somehow uncontrollable) elements, but is very much constructed, mediated and delivered to the viewer for consumption. More news, at any time; more journalism, universally coded; more events, thanks to the multiplication of newsworthiness. Information then becomes a surrogate, rather than a reproduction of the substance of things: what we get from media news is that something newsworthy, and different from yesterday, has happened. (Back in 1934, Benjamin called this attitude the 'avid impatience for fresh nourishment every day' [Benjamin 1978: 223].) Is the content of reporting, whose sole quality is to obey the dogma of being new, still relevant?

> Rupert Murdoch's News Corporation is a media company spreading its activities in America, Europe and Asia. News Corp. controls hundreds of information businesses including newspapers, satellite, cable and terrestrial TV companies, and internet providers.

The main problem resides in the gap between the actual documented occurrence and what journalists choose to read or not read into it. Professional journalism claims a number of responsibilities and duties, like providing information in a balanced and impartial manner; acting as a watchdog for social, economical and political deviance; facilitating public debate – in this, constantly (and successfully) employing visual and textual symbolism to supply its images (Huxford 2001). In fact, a range of other types of outcomes are attached to traditional journalism: 'giving voice to the powerful; occluding or dissimulating dissent; constructing consensus; advocating and championing causes; expressing cultural differences; telling mythic tales; and bearing witness' (Cottle and Rai

2006: 169). What relationship between media and aesthetics is useful to establish built-in critical tools? Certain journalism, more related with forms of art or literature, stands out for a particularly enlightened approach, like the work of Ryszard Kapuscinski: never presenting his findings as the true depiction of reality, but constantly highlighting his partiality (and deficiencies) in the pursuit of truth (Aucoin 2001: 13–14). This type of approach, where the author constantly reminds readers of the incomplete information upon which accounts are made, and the necessity to challenge one's own writings, remains quite rare. Instead, traditional journalism avoids these implications by separating editorial comments (which do not require objectivity) from the news (which apparently does), therefore demarcating two different areas of action and two different modes of criticism and public debate.[5] It might sound as if there is no 'correct' (traditional) journalism; and it might be so. Since its dawn, journalism is implicated in a constant struggle between its ethical mission and its power position, and there is no easy solution. The very debate on the responsibility toward 'truth' is better framed in terms of what kind of 'truth' we feel most responsible for. Perhaps only over time – constantly and methodically assessing what could be important or superficial – can we untangle our position (as producers as well as information users: see Chapter 5), in relation to what happened, what might have happened, what could happen and what is represented.

Art's chance

An aesthetic approach to journalism and fact reporting is a mode that relates to reality and our experience of the world: art is another attempt to represent the environment we live in, and the way we experience it. If journalism at large can be considered a view of the world (of what happened and its representation), then aesthetics would be the view of the view: a tool to question both the selection of the material delivered, and the specific reasons for why things are selected. 'Art turned into an instrument of experimental journalism' (Gheorge 2007) could be one of the practicable ways to mediate information and prompt initiative. Knowledge and aesthetics are not necessarily opposites: this is only the (Western, philosophical) idea that pleasure, because it strives to achieve a state of wellbeing and pathos, cannot produce 'real' knowledge.[6] For journalism, to include or be included with other formats of information (i.e. the arts) might result in opportunities rather than limitations: we need to query not the way art and journalism transform the world, but the way they can transform the meaning of the world (Flusser 2000). To go beyond the formulas of professional journalism is a step to understand (or not understand in a meaningful way, see Chapter 7) the reality we are living; otherwise, we look at our world without going further than its appearance. Historian Paul Nolte addressed the fact that culture is increasingly crucial to understand the world we live in. For instance, up to 50 years ago the economic mechanisms were the basis of understanding our experience as members of a given society; now, cultural

dynamics have gained the upper hand. The modern (of the past century) criteria of science and economics are no longer sufficient for a proper view of the world. The so-called cultural clashes of our age, and the influence of mass media culture on our society (wherever we live), make this shift evident. In order to reconfigure our social and cultural horizons, we should artistically 'process' our everyday life events, and make art and culture become essential: in other words, we have to 'rethink society in cultural, yes, even in aesthetic terms, now and in the future' (Nolte 2004: 4). I draw attention to this point because one of the main aspects of aesthetic journalism: to bring the investigative tradition back to a societal or political function, implies more than changing the site of reportage from press or TV to the art exhibition. Creativity has to widen its boundary perpetually, even accepting stratagems of 'creative cheating': working to generate a space for communication where there is none, abusing an assignment to pass on to the reader, viewer or listener a range of different information. Topics deemed as too uncomfortable for the news arena can be validated in other contexts (like music or visual art) as an acceptable subject to discuss. The perceived problem then, is reintegrated into the social discourse. Many questions arise from the cross-fertilization of journalism and art: is an aesthetic approach a viable path to bring in critical potential? Can art reinforce investigative journalism, which today has to struggle against lack of time? Are artists and filmmakers, who

I borrow the expression *creative cheating* from photographer Oliviero Toscani. In the 1990s, Toscani authored Benetton's ad campaigns using images of war, famine, illness, etc. in order to sell clothes. In his intention, this unveiled the hypocrisy of 'normal' advertising, which at the same time proposes glamorous images side by side with human tragedy.

adopt archive research, interviewing and documentary, able to counter-balance the effect of media manipulation, using the same mechanisms?

Often artists who borrow 'tools' from media news do not question enough these means of representation, as I did not with my own commission on the Istanbul bridges. In the many biennials and large-scale exhibitions that occupy today's cultural panorama, artworks often address social, political, humanitarian and environmental concerns in the language of investigative journalism. This way, documentary, photo-text reportage, archival research and interviews give new relevance to the contemporary art environment, almost as if art – also thanks to the technology of the digital image – had a privileged access to a non-censored form of communication. It is not that the urgency of certain issues has only gained visibility in the arts; rather, this urgency is currently so high that artists cannot leave it outside their practice, and feel the necessity to 'inform' the public. However, in order to go beyond the linear way of proposing a 'true' version of the real, it is also necessary to invent a new language to tell the urgent story. The point is that art is not about *delivering* information; it is about *questioning* that information. Art does not replace the journalistic perspective with a new one, but extends the

possibility of understanding the first – where journalism attempts to give answers, art strives to raise questions. Since there is no true account except for that part of it which we experience first-hand, the urgency is on two levels: in content and in aesthetic proposition. One way to deal with this is to keep telling the story, but to make clear that the language is prejudiced *per se*. The problem we have today is that a lot of journalistic art merely attempts to disseminate information in a way that is allegedly neutral; an artist is not better at producing a more transparent picture of the real than a journalist. What the artist can do better, instead, is to construct a self-reflective medium, which 'coaches' its viewers to ask relevant questions by themselves, instead of accepting (or refusing *tout court*) representations as they are proposed.

I am not the first to propose that the reciprocal nourishment of journalism and artistic practice cannot take place only for a particular (art) audience, as it is currently doing, but rather should enter the expanded field of media culture. Theorist Hilde Arntsen, for instance, provocatively advanced the idea that the spectacularization of journalism, the entering of the realm of popular culture by journalism, might not be such a bad thing, if there are the 'structures on which to hinge this kind of journalism' (Arntsen 2004: 72). Fiction is clearly not journalism, but the latter is not a mirror of reality either. The documentary format itself, for instance, which is often associated with investigative journalism in the search for 'the real', does not reflect any given truth: it rather constructs one (Chapter 3). The idea of document itself – the foundation of the journalistic attitude – is the result of a system of legal authentication (the original photograph, the official certificate, the historical report), which ultimately is a procedure of agreement upon a reality proof. In other words, documents exist within a process of debate and accreditation, and precisely thanks to this procedure can be authenticated.[7] The more documents we have, the more reliable the account; a neutral point of view is assessed when it is shared by a large enough number of people (otherwise it would be a particular point of view). This aspect is neither important nor sought after in art, and the artist's approach barely responds to the expected standards of professional journalism. Case in point, the most effective political works presented in *Documenta 11* were not documentary in the traditional sense, but those which focused on the device of documentary and filmmaking itself, insisting on details, fragments, stop-frame and other self-questioning narration modes. I take as examples two artworks, both significant in this sense, the first of which, Zarina Bhimji's *Out of Blue* (2002), is a film about the destruction of Uganda under the regime of Idi Amin, which tells the viewer the harsh

Documenta is an exhibition taking place in Kassel every five years since 1955. In the post-WWII climate, Documenta aimed to present a survey of the state of art after the horrors of the war, particularly in relation to Europe. This regular event considerably helped to shape an idea of art not as an autonomous field, but as a practice investigating (and reporting) the social and the political via aesthetics.

reality without actually informing about what went on there: 'the work is not a personal indulgence; it is about making sense through the medium of aesthetics' (Bhimji 2002). Representing abandoned sites, with the camera almost surveying the stillness of the location, combined with an eerie soundtrack which somehow heightens a feeling of underlying threat, the documentary 'experience' as a whole compensates the narrative void; something that current media journalism cannot afford. Steve McQueen's film *Western Deep* (also presented in Documenta 11) walks on a fine line between a reality effect and an artistic approach, and takes the viewer on a vertical journey into a gold mine in South Africa. This 'documentary' leaves the audience literally in the dark as to the nature of what is going on in the work; the film generates a feeling of being inside the mine, rather than watching it from the outside. In productions like these the documentary, photo-reportage or text-based research is transformed into hybrid information that appeals to a need of knowing, but also to the curiosity, imagination, fears and desires of the public.

Here aesthetic journalism plays a crucial part. The pressroom journalist has to access multiple layers of source in an attempt to tell the entire story from as many angles as possible, but struggles to gain a relative space of manoeuvre, lacking the possibility of autonomous fieldwork. The artist-researcher, instead, like the investigative journalist, assumes the role of the narrator and takes responsibility for the facts reported. The information is distributed through a series of artistic 'platforms' such as museums and art galleries, cultural programmes (often involving several countries, like the EU programme *Culture 2000*), art magazines, university conferences and online forums. The combination of all these platforms forms art 'discourse', that is, the activities and themes produced by art. The exhibition is not the main feature, nor the concluding one: the set-up of screens, monitors and printed material is usually only a moment of an articulated aesthetic experience, and it serves as an occasion for something else to happen. It functions as a segment of a bigger system of knowledge production. To some extent, the venue hosting the event is interchangeable, since all platforms are, or could be, independent.[8] The elements of this information process are 'consumed' by the viewer either sequentially (as a whole corpus of investigation) or singularly (as an event not necessarily linked to what preceded or follow). This is what distinguishes an artistic information process from a journalistic one: not adding singular parts to produce an algebraic result, like as in the daily accumulation of journalistic reports, but rather generating each time an attribution of sense by the viewer. Other forms of popular culture – although very different in aim and critical approach – constantly question our given notion of factual reporting: for instance, an entire range of media products featuring 'documentary style' and 'realism approach' characterizes every television season. Fact-report, facticity (the presentation of documents as facts), faction (fact + fiction) or straight fiction, all represent varying degrees of that staging of reality, which can also be read as the re-production of the substance of things. My argument is that one cannot really speak

the truth about something, but can manage to get closer to the real by constructing a model of it. In the end, the ability to imagine is closely connected with the *possibility* of change, and this is the potential residing in all forms of cultural production.

The process leading up to aesthetic journalism can be considered from both perspectives: as art being absorbed by the generalist media industry, or as journalism becoming a (common) art form, which ultimately could produce interesting developments. As discussed in the beginning of the chapter, both artists and journalists make use of aesthetics, and are well aware of it: in turn, any act of interpretation, even the most disinterested film or written piece is anything but neutral and is as being coded as a Hollywood movie (Nash 2008). Journalism was born with built-in subversive power, but it seems to have lost its drive, constantly compromising its autonomy and mission. Art and other forms of 'aesthetic' information, like documentary, online projects and advertising (see next chapter) has become an expansion of (and in some cases an alternative to) mass-media journalism: 'art (literary journalism included) is not merely an aesthetic experience, but a way of knowing the world' (Kvale 1995: 23). If journalistic practice is eternally involved in the dispute between ethics and power, art too pulses between two directions: aiming for a particular audience (the art audience), and pursuing something beyond the artistic field. Artists strive to get things more real than reality, more influential than politics, more relevant than economics. They are permanently on the edge between a call for elitism and an attempt to grasp forms of popularity, in the hunt for a critical mass. In particular, non-fiction works by artists are quite often uncritically exchanged for reliable information, and artists themselves tend to proceed in a 'neutral' way in order to validate their work. But the observation of a phenomenon is part of the phenomenon itself, and the only way for an author is to reveal the system by which reality is produced, that is, when he or she creates transparency of the aesthetic means. A language (and art, as well as journalism, is a language) is the result of an ideological and societal process: even a dictionary is always the product of a certain ideology. Philosopher Ludwig Wittgenstein summarized very well the concept that language is public, and cannot be private (Wittgenstein 2001). The problem occurs when an artist feels obliged to strip down their investigative work to bare facts. To act in a relevant way (socially speaking) means to use different styles and codes of communication, and to vary one's vocabulary and grammar structure according to different contexts. A journalistic report, an artwork or a literary narrative would not fill the gap between reality and its representation but reveal it, generating a story with an inner self-critique. A fictitious or aesthetic approach does not necessarily mean that the work is irrelevant or useless. If we were to climb a building any single ornament and decoration could be useful. By challenging the aesthetic dogma of

For Wittgenstein, language is a multiplicity of games: words are defined by how they are used in specific contexts and ordinary communication. Language function and meaning derives from the conventions established by the community as a whole, and not from a private attribution of sense.

and decoration could be useful. By challenging the aesthetic dogma of what truth looks like, aesthetic journalism can tempt mainstream journalism to reconsider its approach. What is produced is not knowledge in the strict sense of the term, but rather – to adopt Jacques Rancière's metaphor in *Short voyages to the land of the people* (2003: 125) – something close to a foreigner's gaze of a city, imagining 'what is, and also what is not' (Lafuente 2007: 23). We get closer to the real not because we use a set of binoculars that do not distort the picture, but because we become aware that we are viewing the world through a set of distorting binoculars.[9] Both artists and journalist face this problem. Artists may be more inclined to do something about it since their work is to take tradition and use it to build the present; this would mean putting in practice an effective form of critique of the present.

Notes

1. In the original text, the passage references also the works of Pierre Bourdieu and Martin Eide, see in Further Reading.
2. In relation of journalistic formats with other fields, see in Further Reading the works by Ulrich Beck, Manuel Castells, Anthony Giddens, and Jürgen Habermas.
3. For an overview about investigative journalism, see in Further Reading the works by Hugo de Burgh, David Spark and John Pilger.
4. Independent multimedia news enterprises such as New York-based MediaStorm are becoming the guiding trend for the distribution of documentary and news, on- and offline. See Mordue, Mark (2009), 'Shoot first' in *Frieze*, Issue 121, March.
5. See in Further Reading the works by Brian McNair, Denis McQuail, and Nico Carpentier.
6. See 'Cinema come filosofia', round table with Giacomo Marramao, Stefano Velotti, Pietro Montani, Umberto Curi, Bernard Stiegler and Edoardo Bruno at the Philosophy Festival of Rome, 11–14 May 2006, in *MicroMega: Almanacco del Cinema Italiano*, Nr. 7/2006, pp. 93–116.
7. This was specifically discussed by three concurrent art exhibitions, which confronted the origins and use of the term 'document': *The Need to Document*, Kunsthaus Baselland Muttenz/Basel (19 March–1 May 2005) and Halle für Neue Kunst Lüneburg (3 April–18 May 2005), http://www.kunsthausbaselland.ch, accessed 6 September 2008. Round-table discussions in Kunsthaus Baselland (6 April 2005), Halle für Neue Kunst Lüneburg (23 April 2005) and in Prague, organized by *tranzit* (27 May 2005), http://cz.tranzit.org/fetcharticle.php?puzzle& page=1196&siteid=22&article=658, accessed 6 July 2008. *Documentary Creations*, Kunstmuseum Luzern (28 February–29 May 2005), http://www.kunstmuseumluzern.ch/archiv/index.html? http://www.kunstmuseum-luzern.ch/pg/fr/main/ausstdocCreations.php, accessed 6 September 2008. *Reprocessing Reality*, Château de Nyon (18 April–29 May 2005), in conjunction with the documentary film festival *Visions du Réel*, http://www.reprocessingreality.ch, accessed 6 September 2008 and P.S.1 Contemporary Art Center New York (6 April–29 May 2006). See also bibliography for exhibition catalogues.
8. See the 'New exhibition' and 'Project exhibition' ideas developed, among others, by Catherine David with *Contemporary Arab Representations* (2002–2006: three exhibitions, five publications, a series of seminars and conferences); and Marion Von Osten with *Projekt Migration* (2005–2006): exhibition, publication, film festival, educational programme, a series of presentations, debates and music concerts.
9. My thanks to Morten Goll for the inspiring metaphor.

Further Reading

Beck, Ulrich (2001), *World Risk Society,* Cambridge: Polity Press.

Bourdieu, Pierre, (1990), *Photography* (trans. Shaun Whiteside), Stanford, Cal: Stanford University Press.

Bourdieu, Pierre (1998), *On Television and Journalism* (trans. Priscilla Parkhurst Ferguson), London: Pluto. First published in 1996.

Carpentier, Nico (2005), 'Identity, contingency and rigidity: The (counter)hegemonic constructions of the identity of the media professional', in *Journalism*, 6, pp. 199–219, London, Thousand Oaks and New Delhi: Sage Publications, http://jou.sagepub.com/cgi/content/abstract/6/2/199. Accessed 24-11-2007.

Castells, Manuel (1997), *The Information Age*, Cambridge: Blackwell.

Chomsky, Noam (2003), *Power and Terror: Post 9/11 Talks and Interviews*, New York: Seven Stories Press.

De Burgh, Hugo, ed. (2000), *Investigative Journalism: Context and Practice*, London and New York: Routledge.

Demos, T.J. (2005), 'The art of darkness: on Steve McQueen', in *October* Vol. 114 (1), pp. 61–89.

Eide, Martin (1998), 'Det journalistiske mistaket' in *Sociologisk forskning*, Sveriges sociologförbund, Nr. 3–4, pp. 69–87.

Galli, Diego (2005), 'Che cos'è il giornalismo partecipativo? Dal giornalismo come lezione, al giornalismo come conversazione', in *Problemi dell'Informazione*, Issue 3, September, pp. 297–315, Bologna: Il Mulino.

Giddens, Anthony (1994), *Beyond Left and Right*, Cambridge: Polity Press.

Habermas, Jurgen (1972), *Knowledge and Human Interest* (trans. J. Shapiro), London: Heinemann.

Habermas, Jurgen (1996), *Between Facts and Norms: Contributions to a Discourse Theory of Law and Democracy* (trans. W. Rehg), Cambridge, Mass: MIT Press. First published in 1992.

Kawamoto, Kevin (2003), 'Digital journalism: Emerging media and the changing horizons of journalism', in Kawamoto, Kevin, ed., *Digital Journalism: Emerging Media and the Changing Horizons of Journalism*, pp. 1–29, Lanham, MD: Rowman & Littlefield Publishers.

Lind, Maria and Steyerl, Hito (eds) (2008), *The Greenroom: Reconsidering the Documentary and Contemporary Art*, New York: Stenberg Press and Center for Curatorial Studies, Bard College.

Massumi, Brian (2005), 'Fear (the spectrum said)', in *Positions*, vol. 13(1), pp. 31–48.

McNair, Brian (1998), *The Sociology of Journalism*, London, New York, Sydney, Auckland: Arnold.

McQuail, Denis (1994), *Mass Communication Theory. An Introduction*, London, Thousand Oaks and New Delhi: Sage Publications.

Mirzoeff, Nicholas, ed. (1999), *The Visual Culture Reader*, London: Routledge.

Pilger, John, ed. (2005), *Tell Me No Lies: Investigative Journalism that Changed the World*, New York: Thunder's Mouth Press.

Rancière, Jacques (1991), *The Ignorant Schoolmaster: Five Lessons in Intellectual Emancipation* (trans. Kristin Ross), Stanford, CA: Stanford University Press.

Spark, David (1999), *Investigative Reporting: A Study in Technique (Journalism Media Manual)*, Oxford: Focal Press.

Wolfe, Tom (1973), *The New Journalism*, New York: Harper & Row.

Chapter 3

WHERE is Aesthetic Journalism?

The blurring of margins between artistic and information practices is a main feature of our culture. At the time of writing, the number of art biennials is topping 150, and large-scale exhibitions and festivals dealing with journalistic research (and their appearance in the media) are a permanent aspect of our infoscape. Besides art, other realms present features closely connected with aesthetic journalism: documentary, the internet and advertising. Documentary, for instance, is a field in which a degree of creative approach has always been present, as the earliest professional documentary films demonstrate. Both *South* (1919) by Frank Hurley (an account of the failed imperial trans-Antarctic expedition led by Ernest Shackleton in 1914); and *Nanook of the North* (made in 1919–1920, released in 1922) by Robert Flaherty (a depiction of how Eskimos lived 100 years previously and how they maintained that lifestyle at the time of the film's release) featured the manipulation of material and the staging of scenes. Flaherty represents the 'template' for the creative documentary director theorized by John Grierson (more below), and the first who structured 'actuality' by means of a superimposed narrative – in short, he not only manipulated the everyday, but also imposed dramatic necessity on the material. We find another (unconventional) contemporaneous approach in the 'reflexive documentary' of Dziga Vertov and his *Kino-Eye* project (1924), a documentary practice rigorous in its attempt to catch life 'unaware' (Vertov 1984, in Winston 1995: 164), at the same time

South and Nanook of the North are highly problematic works in their 'primitivism' approach to local communities. They, in fact, are the beholders of the Western, white, male gaze; in short, of the claimed supremacy of the white race.

making the viewer conscious of the production process (reverse montage, inclusion of the cameraman in the frame and so on). From an abstract 'documentary value' point of view, to disclose non-factual mechanisms, plainly stage them or disclose the act of representing can reveal the core of reality far better than a factual representation. The way these features are then used in the context of a film or outside it, and for what purpose, is another matter altogether. In my research for this book I often crossed paths with the online world, where the ambiguous side of aesthetically dominant information is evident. This led me to think about the internet as an additional realm in which to observe the production and distribution of aesthetic journalism. Web content featuring parody making, and the fragmentation and problematization of mainstream news often combines the idea of journalism as public service with that of artistic experimentation; it will be interesting to see how this aspect has developed in recent projects. Following visual art, documentary and the internet, the fourth realm touching the aesthetic treatment of

information is advertising. This creative force, constantly scanning social behaviours to appropriate them and use their values, although driven by the market and not by cultural objectives, is capable of bridging aesthetics and information in a very effective way. Even more interestingly, the co-option of a social form, that is, when a social style or behaviour, generated bottom-up in the course of time, ceases to be true to its original function and origins and becomes 'marketable' by the culture industry, is often taken back as cultural product and re-worked in a critical way.[1] In line with this, commercial and industrial conglomerates such as Shell, Siemens or Benetton actively use an artistic-journalistic approach to promote their company culture, and apply journalistic methodology to corporate art projects and 'social responsibility' campaigns.

Art's context

During the 1960s, cultural institutions accommodated artists' critique towards their own function and representation policies, and promoted the research, discussion and query of a wide series of issues in the social and the political. Such practices were further established in the 1990s with the commissioning of art projects frequently based on journalistic investigation. Venues like Witte de With in Rotterdam or KW Kunst-Werke in Berlin, artist-in-residency or fellowship programmes and gatherings like *documenta X* and Documenta 11 in Kassel or Home Works in Beirut, and a vast number of biennials worldwide (from São Paulo to Gwangju, from Istanbul to New York), since then have offered alternative accounts of history, situations and populations. I spare the reader the list of the countless 'journalistic art' projects presented in those contexts – I will present a selection in the sixth chapter. However, since it is important to understand concretely what is at stake, I briefly outline one of the examples discussed later in the book. *One Step Beyond* (2001–2004), by German artist Lukas Einsele, is a prototype of the journalistic attitude in art. The project is produced by Witte de With, and has been exhibited (until 2008) in Rotterdam, Krefeld (Museum Haus Esters), Karlsruhe (Badischer Kunstverein), New York (UN and Goethe Institut), Berlin (Martin-Gropius-Bau), Stuttgart (Akademie Schloss Solitude), Umeå (Bildmuseet Umeå University), Darmstadt (Galerie der Schader Stiftung), Thessalonica (1st Biennial of Contemporary Art), Malmö (Malmö Museet). It is also travelling to the countries where the material was gathered: Angola, Bosnia-Herzegovina, Cambodia, and Afghanistan (Goethe Institute in Kabul, 2007). What kind of work is *One Step Beyond*? In the handout *Work in Transit*, released in October 2004 for the presentation of the project in Rotterdam, I read:

> Over recent years, Lukas Einsele has been studying the worldwide phenomenon of the landmine and its victims. He travelled together with photographer Andreas Zierhut to minefields and other areas in Angola, Afghanistan, Bosnia-Herzegovina, and Cambodia. Einsele's work explores the interrelationships between landmines and their

victims against the backdrop of global politics, revealing his findings in the form of photos, graphics, texts, and interviews. With the specific cohesion of the various visual elements and project components [website, presentations, publications, and installations], Einsele strives to articulate a new aesthetic and political space, in which a wide range of information and visual materials can be communicated and presented to the public in a distinctive manner.[2]

Reading the list of venues hosting the project, one wonders whether art institutions are the only places where an alternative, complementary account of the world is possible. In principle, an exhibition room allows an audience that space and time to debate what is lacking in other realms, especially that of mass media. In the end, this is what art is supposed to do: to pose questions. Answers are to be sought in design, or science; but questions are definitely pertinent to art. Could an artwork based on journalistic criteria provide a valid account and claim authenticity, could it be a subjective interpretation of what actually happened? Are we able to generate reality through language, interactions, storytelling and performances? (Jameson 1991). OSB gives to the victims of landmines the opportunity to relate their account of the day of the accident and sketch a drawing of its location. This, in turn, raises issues about international law, war and profit. Yet, I admit that despite my (and Einsele's) best intentions, my experience of the exhibition was such that – in transposing the matter to the white walls of the art institution – the whole concept of the alternative account vacillates. The clinical setting of the gallery (at least in Rotterdam, but I suspect it is replicated elsewhere) puts the viewer in the position of the ethnographer in front of raw material. Moreover, it is designed to be accessed within the art context; only an audience that chooses precisely that sort of show might get that 'distinctive manner' assessed as a value. This is not to diminish the importance of the topic addressed, or to criticize art spaces for being unable to address everybody: any form of cultural production has its own audience, more or less specialized, and art is no exception. What I am wondering is something different: is the artist here assuming an ethical position, not about the represented subject, but regarding the process of making it visible? After the artist as ethnographer, working horizontally from social issue to social issue, and treating conditions like desire or disorder as sites for work (Foster 1996), do we have now (or have we had so far) the artist as journalist? This latter configuration would not enter a specific community or a problem, and then pass from one to the other; it would rather work vertically, re-appropriating a relationship with a specific medium (in this case, the technique of journalism) and exploiting its potential.

Sure, the 'committed' artist has a duty to criticize the society he or she lives in, his or her contemporaries and the accounts they produce: this is a precise task for any ambitious cultural producer. The major threat one faces here is to become ineffective and socially anesthetizing for the public; conceiving of a social and political document *a priori*, and only afterwards researching a story to illustrate it. The art institution that sustains the production

and distribution of journalistic art, for its part, risks developing a kind of politics per se (Rogoff 2002, Kortun and Esche 2005) – a politics in itself instead of working on politics.[3] To step into a museum or biennial with dozens of video screenings about war and displacement, statistic graphics and photojournalistic reportage, may give the unpleasant sensation of a routine of reporting and cartographic visualization; each implying a very limited critical practice, and not communicating 'properly' with the viewer. Art exhibitions displaying what one might as well receive by watching CNN, seated on the sofa, are probably not appealing for a potential public that gets its worldview via CNN – and that is exactly the sore point. Journalistic art, as outlined above, risks becoming a genre devoid of any influence, because it works on a very circumscribed audience, and does not try to enlarge it; also, it does not develop its own mechanisms of narration, and relies on borrowing photo-reportage and TV-journalistic style. It is not a matter of substituting journalism with journalistic art, but rather of confronting this public service with a different mode of address. To achieve this, the artist has to work on the inner sensibility of the viewer, and not on their visual capability. After all, literature and artistic experiments have always preceded journalism and popular culture (Jonsson 2004): from avant-garde film aesthetics becoming the norm in TV-editing techniques to the influence of painting iconography on photojournalism, via nineteenth-century realism establishing the visual pattern for documentary making. Far from being perfect, such an aesthetic use of journalistic methods – when produced and delivered to the point – could claim a key function in society.

Documentary

The filmmaker and critic John Grierson is commonly credited as being the first to use the term documentary in a 1926 review of Robert Flaherty's film *Moana*, as a definition for any non-fictive cinematic medium, including travelogues, educational reels and instructional films. Although this paternity is only due to the abilities of Grierson as publicist,[4] the idea of documentary as image-making of a pre-existing reality through the 'creative treatment of actuality' (Rotha 1952: 70, Grierson 1996: 100) was established. The term documentary itself derives from connecting document with authenticity and truth. Today we interpret the term 'document' with connotations of legal and official status: we need to agree upon its status for an object to become a document. This legal concept is quite central to the idea of documentary both for its 'scientific' evidence, and for the interview technique; yet shaping and treating elements of reality to arrange comments in order to disclose 'the real' was present from the very beginning of documentary filmmaking. The claim of objectivity (the facts, from a neutral point of view) and realism (the facts, as they happened) were somehow hybridized, as Grierson's definition clearly indicates: the factual and the real were considered channels superior to fiction as *interpreting* tools of the (modern) world, not as representing techniques. Establishing the authenticity of a document is not a univocal process of determining truth, but rather a

discursive technique: the same goes for documentary making which is, first, a discursive art form. The truth-value of it relies upon a shared set of values: the idea, the author, the production, the audience and the distribution. In other words, this belief-system depends on the viewer's interaction with the artwork/document/object presented: we can appreciate or dislike the information that the documentary offers to us, but all this comes after we have agreed upon its technique. In time, the genre gradually abandoned its feature of sobriety, and a number of works paved the way for its re-articulating. I am thinking of the early experimental films made by combining 'authentic material' in different ways to reveal the essence of facts, starting with *The Fall of the Romanov* (1927) by Esfir I Shub, which juxtaposed found shots of the Tsar's home movies and newsreel footage. *A propos de Nice* by Jean Vigo (1930) and *Land Without Bread* by Luis Buñuel (1933) both presented a mix of street footage and constructed scenes; the same goes for the 'pre-docudrama' *Redes/The Wave* by photographer Paul Strand (1936) and, changing medium, the (in)famous radio piece *The War of the Worlds*[5] by Orson Welles (1938) – an alien invasion broadcast live with little mention of its fictional nature. All these early ideas expanded documentary in a number of sub-genres such as the film essay, known also as docudrama or docu-fiction: half documentary based on archive material, half movie that fills the gaps in-between (remarkable examples include the quasi-biopic works of Isaac Julien, *Looking for Langston* (1989), and *Frantz Fanon: Black Skin, White Mask* (1996)). Other outcomes of the documentary-genre expansion are reality-TV programmes, infotainment (information and entertainment) formats and mockumentary (mock documentary). Some of these approaches have been very successful in terms of audience, like the film essay *Fahrenheit 9/11* (2004) by Michael Moore, the first work of this genre to cash more than 100 million dollars in the United States; or the globally known staged reality show *Big Brother*. The mention of a reality show in the context of documentary practice may raise some eyebrows, but fear not, as it is nothing new. In his book *Claiming the Real* (1995) Brian Winston mentions the 1964 film *A Married Couple* by Allan King, in which director and crew, despite living with a married couple for months and turning their house into a set, presented the film as a sort of sociological document of 'true life'. Documentary makers also construct fictional reports inspired by facts, in order to make the viewer experience what happened; or produce films styled as documentary, which construct a fake reality. A few examples are the re-enactments of situations, episodes and history narratives, like *The Milgram Re-enactment* (2002) by Rod Dickinson, which reconstructs the subjects' propensity to comply with authority; and Peter Watkins's *La Commune* (1999), on the events in Paris between March and May 1871. Other peculiar instances are the self-re-enactment of Dieter Dengler (the subject of the documentary) recounting his own capture in Vietnam in *Little Dieter Needs to Fly* (2006) by Werner Herzog; and bogus fight films of early cinema – including that of 1905 by Sigmund Lubin, who filmed a reconstruction of the boxing fight between Jim Corbett and Charles McCoy. With the mockumentary, fake material is presented as documentary: from amateur-like

shooting techniques in the horror drama *The Blair Witch Project* (Daniel Myrick and Eduardo Sanchez, 1999) to the chameleon-man *Zelig* by Woody Allen (1983), via the heavy metal band story *This Is Spinal Tap* by Rob Reiner (1984). Other examples are the TV series about the US-senator campaign *Tanner 88* by Robert Altman (1988), the story of the cinema pioneer Colin McKenzie in Peter Jackson's *Forgotten Silver* (1996), George W Bush's assassination in *Death of a President* by Gabriel Range (2006) and Brian De Palma's view on the Iraq war in *Redacted* (2007).

All of these films, whether negotiating a distorted reality or using archaeological work, adopt documentation not to present factual evidence, but to evoke it; and in one of the latest turns of documentary, a 'personalized story form' coming from online blogs has been identified as a new trend in documentaries (Aufderheide 2000, Wall 2005). In short, if we consider documentary in relation to the search for truth, we miss the point: the factual quality of a film or video, in which the viewer can recognize a list of facts that supposedly happened, dissolved a long time ago (Nichols 1997, 2001). We cannot speak about a 'whole truth', but only about moments of truth, throughout a variety of means in time and space. What we get from official documents or witnesses are only moments, which can then be articulated in a narrative (past, present or future) by the viewer, and not simply presented by the author *as* truth. In documentary, aesthetic and investigative journalism alike, the access to visualization (the possibility to obtain visual material) is what determines what is investigated and what is left out. The access to the possibility of image is the watershed for what can fit into a narrative accessible to the viewer and what cannot, or should not, be represented. This becomes evident when such a 'truth-format' is brought into another context (like art, or advertising), since it does not necessarily represent a document. As TJ Demos points out (2006: 85–87, 2008: 6), artists reinvented the documentary mode, simply by avoiding the assumptions of objectivity, impartiality and transmission of facts, which documentary shared with its media counterpart – photojournalism. By staging, re-enacting, suggesting and evoking what supposedly took place, the documentary form creates the reality that is only purported to document (Steyerl 2003). One of the crucial issues to discuss in relation to documentary filmmaking is to question, besides what is reality, also the means of representation. Some strategies here might be useful. For instance, one could attempt to define documentary by using a receptive criteria, that is, depending on what the viewer expects from it, and what he or she concludes about it:

> All documentaries – whether they are considered, in the end, to be reliable or not – revolve around questions of trust. A documentary is any motion picture that is susceptible to the question 'Might it be lying?' (Eitzen 1995: 81)

When a documentary approach is included in fiction, Eitzen's interrogative could be re-phrased: asking whether what is seen on the screen has actually taken place. Inverting the question (whether a documentary might be telling a possible truth rather than a

possible lie) helps to understand the genre of constructed 'real' narrative: it primarily depends on the viewer believing its hypothesis. The creative input in reportage encourages the audience to ask which of the documentary elements are necessary to claim the authenticity of a document. It does not try to convince the viewer of the truthfulness of the image by increasing its credibility; rather, it urges the audience to question the content, and the language used to address it. Thus, the fundamental question becomes: could that be true?

Internet

The web altered our relationship with information, first of all as consumers of the data that fluctuates through the net. The definition for anyone using the internet actively is prosumer (producer and consumer), since it is possible to circulate rapidly and effectively accounts and images, and initiate (either via text, video or audio) an interaction with any other individual connected to the internet; something previously reserved for the professional categories of the information industry. The web, being an assorted formation of individuals, corporations, institutions and governments, provides a general structure for millions who – through their presence and their exchanges – open up the possibility to inform other millions, and influence social processes; it has generated our networked media culture. It is the place of resistance to authoritarian control of information, as well as an influential tool to increase control and power on a global scale (for instance, in finance and trade). We have Ubuweb, YouTube and MySpace, where challenging, competent and serious content (i.e. educational courses on video by universities) is present alongside the swollen ego of a myriad of users: on the video-sharing platform YouTube, the material ranges from naïve to extremely complex, from pure entertainment to politically shocking. All this lies within constraints of quality, time and background information, not to speak of the 'bracketing' of the single video with any kind of other (sometimes unrelated) content, beyond the control of the author. The internet in this case becomes a 'viewing portal of the past' (Holman 2009), its real function a further option for the distribution of ideas rather than an interrogation or a replacement. In fact, despite the potential to bypass official media channels and international borders, the web includes – as in the offline world – cases of heavy censorship hidden behind the supposed freedom of exchange. Information about the Tiananmen massacre from within China or criticism of Islam from within Saudi Arabia are almost impossible to find, as are many other phenomena I am not aware of.[6]

In any case, certain features of the web-scape have had a profound impact on the style and distribution of the mainstream news. The spreading of blogs, the diary-style websites updateable weekly or daily without any particular knowledge of web technology, undermined the principle of institutionalized information. As mentioned above, non-professional operators bring to surface situations, stories and news that usually do not

make the prime time, either due to the alleged disinterest of a broad audience or through precise ideological reasoning. The web has therefore widely influenced the profession of the journalist, previously the only producer of the representation of facts. As seen in Chapter 2, if once we could expect a journalist to wander about searching for this or that piece of information, which could qualify as tomorrow's news, nowadays a growing amount of professionals barely move from their desks, as fieldwork is shifted to desktop publishing. The news-worthiness of information is what renders the difference between a fact and a fact that makes the headlines: 'news is, in effect, what is on a society's mind' (Stephens 1988: 9). Now, since the core of the journalist profession lies in the process of making the news and not in the news story itself, what is the relation between internet journalism and aesthetic journalism? How do they interact with traditional journalism? The possibility opened up by the internet to play with its own means of production allowed artistic and journalistic practice alike to occupy positions previously foreclosed. In 2007 the weekly supplement to the Italian newspaper *la Repubblica* featured an article about the phenomenon of citizen journalism and amateur video. According to its author, non-professional citizen reporters produce 70 per cent of the media images of natural catastrophes and terror attacks (Casolari 2007). I have not been able to find a source to back up this information, but I am ready to give it a chance; if not now, it will happen at some point in the near future. This would mean that professional journalists do *not* make the major part of the production of information, even if the most visited online news channels belong to established press and broadcasters. The reason is obvious: the amateur reporter happens to be on the spot, with a camera integrated in his or her mobile phone, ready to record images long before a reporter would be able to shoot anything. News media are increasingly interested in using images and sounds made by amateurs; despite weaknesses in compositional and quality standard, 'outsider' material is felt to be more revealing than that produced by professionals. The first-hand images we get on television, newspapers and the internet are the result of a geographical and social fragmentation of the production. Slowly but inexorably the feeling that handheld-camera and low-quality video are somehow the most truthful means of representation has taken place in our collective imaginary. The evaluation of the effects of this multifaceted phenomenon is something that cannot be accommodated here. This 'distributed knowledge' is now the subject of university courses and web communities like *Nettime.org* and *IDC* (Institute for Distributed Creativity)[7] that constantly discuss the criteria for evaluating such a phenomenon. Online communication does not include only blogs, citizen journalism and social networking, but also distributed art, game interactivity, literature and design production, political watchdogs, activists' groups and information-sharing websites that document what falls below (or stops short of) the 'radar' of mass media. Multimedia artist Michael Takeo Magruder, for instance, undertakes journalistic investigations by sourcing third-person material to build a highly individualized narrative of the facts reported. In his work *Fallujah. Iraq. 31/03/2004,*[8] he employs AP/Associated Press and BBC material

on a tragic event (the killing of four American mercenaries by Iraqi insurgents) to propose an idea of 'truth' that he wishes to convey. The aesthetics of the work, with its use of audio and video re-mix, makes clear to the viewer that what is proposed is his personal attempt to cover an event that has been censored by mainstream broadcast media. Artist Antonio Muntadas has created an accessible online archive of censorship in the history of humanity accessible by state, period and type of work or information covered up;[9] *The Speculative Archive*, a web project by Julia Meltzer and David Thorne, uses declassified government documents to publicly argument notions of history, politics and documentary forms.[10] On a more activist level, the artists' collaboration Josh On and Futurefarmers created *They Rule*, an online archive-style project which depicts graphically the links between the most powerful figures in American corporations, providing an up-to-date panorama of who is deciding what, and through which power mechanisms.[11]

How does this freely available information change the journalist's approach? My guess is that all this results in a new deontology for the journalist, which establishes the need to have multiple angles on a story. Thanks to the enormous amount of data available online, the individual (that person who lives in the internet-connected third of the world) can access information regarding public administration, community and international affairs, decisions and criteria in public matters. Organized (thematic) online networks offer an almost infinite pool of material to tap into, and either browse and pass by, share or collect and use in a different way. In this last case, the process of net-sourcing assumes the same principle (if not the same outcome) of the fieldwork process of the investigative journalist. These sources spread information outside the norms of professional journalism, sometimes bypassing the 'gatekeeper' of government agencies or corporations. Interestingly, while the journalist has to get the entire story from as many different perspectives as possible, bloggers re-source material for their articles mainly from the mainstream media, closing the loop they first initiated. Mass-media journalism actually gains status from the very things that attempt to undermine it: despite being fragmented and re-articulated in endless ways by prosumers, news from established broadcasters and newspapers is still the most 'clicked' as it is endlessly perpetuated through the net, generating a domino effect from which journalism feeds itself. This also means that a news item is indeed a social product, something that does not stand as an isolated episode, but rather reflects 'the values of its context' (Wall 2000).

Advertising

Advertising is creative communication that consists mainly in generating the aesthetic experience necessary to awake a desire for an item, status or feeling. As a technique, advertising creates message and stimulation in the public sphere designed to increase the consumption, and subsequently to reinforce the loyalty towards a commercial brand or policy. In doing so, even critical art and film formats are used to achieve the needed results,

as in the case of the co-option of the documentary genre by corporations of the oil industry and television networks as early as the 1940s (Sekula 1999). In recent years, in societies with a developed economy, advertising subtly changed its main function and now is designed to 'help' the consumer in finding their own way of life, rather than convincing them to purchase something. No more someone to target, but a person who actually chooses what advertisements they want to view and thereby helps to spread the news (Comcast Spotlight n.d.). In other words, we are no longer passive targets but 'distributed actors' (Lovink 2008) who actively promote commodities almost as universal human rights. The circumstance of advertising becomes increasingly relevant as the message shrinks to unobtrusive, rather than overwhelming. In this process, advertising has taken over communication in realms exceeding the commercial value: we have social advertisements, which appeal to citizens' responsibility beyond the monetary factor (volunteering, health, ecology and so forth); and governmental communication intended to provide citizens with advice and update on services, and promote the government's agenda in this or that field. To this type of communication belongs, strictly speaking, advertising by interest associations (either political or economical organizations), religious and civic groups, and military or paramilitary forces. If we focus for a moment on the visual aspect of communication and consider investigative journalism – either in traditional or artistic terms – we realize that the process of starting research is centred around the idea of making it visible: an investigation is more likely to be assigned and concluded if the author has access to good visual material. The value of aesthetic data in journalistic research corresponds to the value of desire (through an aesthetic appeal) in the commercial world. This triggers a reaction to this form of commercial communication by artistic and documentary practices, aiming to balance the growing influence of marketing strategies in the social, cultural and political realm. We witness therefore the rise of the 'documentary position' (Havránek 2005b) as a critical stance – a sort of counter-strategy of authenticity – by artists and filmmakers. However, as advertising techniques are the real currency for the attention of the viewer, art (and documentary) practices cannot ignore this fact if they want an audience. Advertising industry and critical art have more than one point in common, in terms of using compelling narratives and aesthetic experiences (if not emotional strategies) as a tool to convey information (H.arta 2006). Both, then, are focused on the idea of change as a necessary step to access something different. Finally, both consider the core of the message (being advertisement or artwork) not for what it says in itself, but for what it delivers in terms of knowledge or the access to a particular experience. This is central in our discussion. As the goal for any business shifts from the occasional sale to the establishment of long-term relationships with clients, so they develop activities that do not directly engage in a transaction, but involve the consumer in sharing a worldview. The multinational Benetton, for instance, sustains a foundation for research and studies (*Fondazione Studi e Ricerche*) and funds projects of microcredits in Africa. This is the first paragraph of the press release:

Africa Works – the slogan of the campaign developed by Fabrica – will appear on billboards and in the press throughout the world, from February 2008. It features Senegalese workers who have used micro loans to start small, productive businesses. Photographer James Mollison portrays them with the tools of their trade against a neutral background. They include, amongst others, a fisherman, a decorator, a musician, a jewellery-maker, a farmer, a tailor, two textile sellers and a boxer. These everyday people become tangible symbols of an Africa that uses the dignity of work to fight poverty, promote equitable development, maximise its resources and take back responsibility for creating its future.[12]

The project Africa Works is amplified by another of the company's parallel projects: the magazine *Colors*, published in English language and distributed worldwide through specialized bookstores and wholesalers. *Colors* is a mixture of a design magazine, a fashion catalogue and an illustrated reportage: it melts all three aspects under a highly aestheticized layout. These projects export, in fact, the company's value through 'design, music, cinema, photography, publishing, Internet' (from the same press release quoted above). They export a vision of the world that is closely linked to journalism: they, in fact, create a system of values. Another case in point is the multinational Siemens, which operates in industry, energy, healthcare, IT and financial solutions, and since 1987 funds an entire cultural programme addressing issues such as: 'Between Profit and Morals', 'Art & Economy', 'Between the Wars. Societies in Upheaval', 'Late Freedoms. Stories of Aging', 'Squandering. Business Needs Abundance – The Positive Sides of Wasting'. Those are the titles of five projects (exhibitions, publications, theatrical interventions, and so on) financed and realized in the last decade, all of them with a strong journalistic and social agenda. Siemens invests part of its profits in funding artistic investigations on universal issues such as immigration, labour and law. Indirectly, these projects function as megaphone for the activity of the company in this or that local region. The third and last example (of many possible ones) is the oil and energy multinational Shell, which supports (discreetly) socially and politically responsible art projects such as the recent 'What is Real? Photography and the Politics of Truth', a two-day symposium at TheTimesCenter in New York on 12 and 13 December 2008, organized by The International Center of Photography. This conference brought together renowned photographers and artists (among others, Walid Raad and Martha Rosler, who I will discuss later in this book) in order 'to examine the changing nature of documentary practice' (Art & Education 2008).

The three cases mentioned here are only an infinitesimal fraction of the companies that approach advertising in a diagonal way. By funding artistic research on current social and political issues, they establish a certain presence in the collective imagery: an asset that does not generate money in itself but which goes beyond products or services. This approach echoes the idea that the cultural sector today is the engine for the worldwide

economy (Galbraith 1998). Marketing experts are called on to find new ways to give cultural significance to the customer's purchases and behaviours. Under this view, the corporate art project informs the audience on a particular situation or theme, and 'instructs' the person on his or her cultural values. Advertising, in this sense, is an interesting field to understand how the relation between the history of the single person and the broader history of culture functions (Rifkin 2000).

Aesthetic journalism could be a sort of reaction to the perceived homogenization of traditional journalism and the globalization of news (networks of corporations controlling information channels). Facts and stories can be omitted or added to shape precise opinions in the public realm. (The saga of the weapons of mass destruction in Iraq told us something about this.) In addition, the development of the web with its space-time compression, virtual identity and Second Life,[13] as opposed to real life, has contributed to establish a longing for the authentic; thus, the explosion of documentary and reporting in the contexts of art, film, advertising and the internet. However, to know that something is there is not enough; how did it come about and how can we use it?

Notes

1. Critic Diedrich Diederichsen exposed this mechanism in 'Polyphilo's dream', an article on the relation between contemporary culture industry (internet in particular) and the culture industry as defined by Adorno and Horkheimer (more on this in Chapter 5). The article appeared in *Frieze*, Issue 122, April 2009 (trans. Nicholas Grindell).
2. *Work in Transit* is a periodical handout publication published by Witte de With to present the institution's programme, www.wdw.nl. For Lukas Einsele's project, www.one-step-beyond.de. Both accessed 13 November 2007.
3. Cultural theorist Irit Rogroff speaks of a 'politics without a plan'. By this, she means that our knowledge acquired through a specific medium of representation (for instance, art) is not immediately 'translatable' into an immediate course of action. In my view, it is relevant to be aware that acknowledging is not the same as acting upon.
4. Brian Winston in his 1995 book (see bibliography) provides evidence that at least two other film professionals adopted the term long before Grierson: Boleslaw Matuszewski in 1898, and Edward Sheriff Curtis in 1914.
5. Orson Welles directed a rendition of *The War of the Worlds* (1898), a science fiction novel by H.G. Wells that describes the invasion of England by aliens. Welles adapted a version as a Halloween special on 31 October 1938, and aired it over the CBS radio network in the States. The first half of the broadcast was a series of news bulletins reporting that an actual Martian invasion was in progress. After the initial credits, the first break came after some 40 minutes, thus generating mass panic in the population.
6. A project dealing with web censorship is Picidae.net: it allows the user to read and visit a censored website in a graphic form. By invoking the pici-server (the server available for this project) from within a country, it creates an onscreen fieldbox to fill in, in which a web address can be typed. Once the information regarding the desired website is sent, an image of the

website is then created and sent back, where it becomes accessible via links navigation. To make the navigation possible, the server puts the links via image maps, so one can click in the web browser with the mouse onto the links like on the 'true' web page, http://www.picidae.net. Accessed 14 November 2007.

7. Two of the main networks for media and research studies, http://www.nettime.org and http://www.distributedcreativity.org. Both accessed 14 November 2007.

8. The online version of the artwork is accessible at http://www.takeo.org/nspace/ns011/. Accessed 20 April 2009.

9. The File Room is a project attempting to define and address censorship. It provides a tool to discuss and to come to terms with the cultural environment producing the censorship in the first place, http://www.thefileroom.org. Accessed 10 October 2007.

10. See in particular the project 'It's not my memory of it: three recollected documents' http://www.speculativearchive.org/itsnot. Accessed 7 August 2008.

11. The project is accessible at http://www.theyrule.net. Accessed 14 July 2008.

12. Benetton Group press release, http://www.benetton.com/africaworks-press/en/press_information/ 1_1.html. Accessed 15 July 2008.

13. Second Life (SL) is an internet-based virtual world launched in 2003, which offers an advanced level of social network and interaction. Its users can meet each other through avatars (a virtual representation of the user), socialize, explore the virtual environment and join group activities. It is also possible to trade items (as virtual property) and services from one another, http://secondlife.com. Accessed 14 November 2007.

Further Reading

Appadurai, Arjun (1996), *Modernity at Large. Cultural Dimensions of Globalization*, Minneapolis: The University of Minnesota Press.

Badiou, Alain (2007), *The Century*, Cambridge: Polity Press.

Bruzzi, Stella (2000), *New Documentary: A Critical Introduction*, London and New York: Routledge.

Creischer, Alice and Siekmann, Andreas (2003), 'Krishnas karies – Zum phänomen universeller kartografie und mode', in *Texte zur Kunst* Nr. 51: *Nichts als die Wahrheit*, September 2003: pp. 46–56.

de Seife, Ethan (n.d.), 'The treachery of images: A history of the mockumentary,' cc Media, Inc. website, http://www.spinaltapfan.com/articles/seife/seife1.html. Accessed 13 June 2009.

Beveridge, James (1978), *John Grierson, Film Master*, p. 292, New York: Macmillan Pub. Co.; London: Collier Macmillan.

Grierson, John (1979), *Grierson on Documentary* (Forsyth Hardy ed.), London: Faber.

Hall, Stuart (1988), 'Media power: The double bind', in Rosenthal, Alan, ed., *New Challenges for Documentary*, pp. 357–364, Berkeley: University of California Press.

Hight, Craig and Roscoe, Jane (2001), *Faking It. Mock-documentary and the Subversion of Factuality*, Manchester and New York: Manchester University Press.

Lasica, J.D. (2002a), 'Blogging as a form of journalism', in Blood, Rebecca, ed., *We've Got Blog; How Weblogs are Changing our Culture*, pp. 163–170, Cambridge: Perseus Publishing. Also published in 2001 (reviewed 2002) on OJR – Online Journalism Review at http://www.ojr.org/

ojr/workplace/1017958873.php and at http://www.jdlasica.com/articles/OJR-weblogs1.html. Both accessed 20 October 2008.

Lasica, J.D. (2002b), 'Weblogs: A new source of news', in Blood, Rebecca, ed., *We've Got Blog; How Weblogs are Changing our Culture*, pp. 171–182, Cambridge: Perseus Publishing. Also published in 2001 (reviewed 2002) on OJR – Online Journalism Review at http://www.ojr.org/ojr/workplace/1017958782.php and at http://www.jdlasica.com/articles/OJR-weblogs2.html. Both accessed 20 October 2008.

Jameson, Fredric (1992), *The Geopolitical Aesthetic*, Bloomington and Indianapolis: Indiana University Press.

Lyotard, Jean-François (1984), *The Postmodern Condition: A Report on Knowledge*, Minneapolis: University of Minnesota Press.

Marcus, G. and Myers, F., eds. (1995), *The Traffic in Culture: Refiguring Art and Anthropology*, Berkeley: California University Press.

Plantinga, Carl R. (1997), *Rhetoric and Representation in Non-Fiction Film*, Cambridge: Cambridge University Press.

Rancière, Jacques (2004), *The Politics of Aesthetics: The Distribution of the Sensible* (trans. Gabriel Rockhill), London and New York: Continuum International Publishing Group.

Rogoff, Irit (2000), *Terra Infirma: Geography's Visual Culture*, London and New York: Routledge.

Rogoff, Irit (2004), 'The where of now' in Morgan, Jessica and Muir, Gregor, eds., *Time Zones: Recent Film and Video*, pp. 84–98, London: Tate Publishing.

Rosen, Philip (1993), 'Document and documentary. On the persistence of historical concepts', in Renov, Michael, ed., *Theorizing Documentary*, pp. 58–59, London and New York: Routledge.

Rosenthal, Alan (1971), *The New Documentary in Action*, Berkeley: University of California Press.

Singer, J.B. (2003), 'Who are these guys? The online challenge to the notion of journalistic professionalism', in *Journalism: Theory, Practice and Criticism*, 4(2), pp. 139–163.

Steyerl, Hito (2008), *Die Farbe der Wahrheit – Dokumentarismen im Kunstfeld*, Vienna: Turia + Kant.

Trinh, T. Minh-ha (1990), 'Documentary is/not a name', in *October*, Vol. 52, Spring, pp. 76–98.

Trinh, T. Minh-ha (1993), 'The totalising quest of meaning', in Renov, Michael, ed. *Theorizing Documentary*, pp. 90–107, London and New York: Routledge.

Verwoert, Jan (2004), 'Research and display. Of transformations of documentary practice in recent art', introduction text in Neuerer, Gregor and Jacobs, Steven, eds., *Untitled (Experience of Place)*, London: Walther König Books Ltd. Reprinted 2008 in Lind, Maria and Steyerl, Hito, eds., *The Greenroom – Reconsidering the Documentary and Contemporary Art*, Vol. 24, Fall, New York: Sternberg Press and Center for Curatorial Studies, Bard College.

Verwoert, Jan (2003), 'Documentation as artistic practice' (trans. Aileen Derieg), in *Springerin* 3/03: *Reality Art*, http://www.springerin.at/dyn/heft.php?rd=36&pos=1&textid=1355&lang=en, and http://w23.calypso.net/ci-119581/se/texts/Nuuk5.html. Both Accessed 13 June 2009.

Winston, Brian (1993), 'The documentary film as scientific inscription', in Renov, Michael, ed., *Theorizing Documentary*, pp. 37–57, New York: Routledge.

Zolghadr, Tirdad (2006), 'Them and us', in *Frieze*, Issue 96, January–February, pp. 31–32.

Chapter 4

WHEN did Aesthetic Journalism Develop?

The relation between art forms and the attempt to build a reliable representation of a society dates back to ancient times. In Europe this was a constant feature, from the inscriptions about war on Greek colonnades and Roman triumph arches to the artefacts of the European Renaissance. This part of the book does not serve as a history of this interaction, but rather highlights a few social and cultural scenarios that produced, in different times, some early patterns of aesthetic journalism.

A few scenarios of the past...

Art forms throughout the centuries were prominently devotional, that is, tools to educate and shape the psychical and physical environment of the population, in order to maintain the subjects' position in a stable social hierarchy (largely dominated by churches). Indeed, especially during medieval times, religions used (artistic) imagery as an instrument to educate the masses about morality and maintain a form of control upon them. From the fifteenth century onwards, at least in Europe, there was an impulse to explore and study 'the tangible' beyond the connections with social hierarchies mentioned above. Observational figures and scientific knowledge began to erode the certainties of faith; not replacing it but, rather, occupying a middle ground: artistic practices were then increasingly conceived as 'data' able to connect with one another. To take the example of Italy alone, the integration of art, science and technology determined the background for the accomplishments of figures like Filippo Brunelleschi (1377–1446), who mastered architectural theory, the one-point linear perspective in painting (which allowed for naturalistic styles) and the construction of theatrical machinery. Or the Renaissance figure of the 'universal man' like Leon Battista Alberti (1404–1472), who worked as an artist, architect, poet, linguist, philosopher, and Leonardo da Vinci (1452–1519), scientist, mathematician, engineer, inventor, anatomist, painter, sculptor, architect, botanist, musician and writer. In this context we can situate the first attempts to build artistic tools (that is, theoretical knowledge and practical realizations) to represent reality, which was seminal for artists, architects or humanists (at that time not so differentiated), enabling their work to be recognized professionally. The educational function was especially pursued in the aftermath of the discovery of the American continent, conventionally dated in 1492, the year of Christopher Columbus' first expedition. The voyage led to a general awareness of the other hemisphere and, importantly, ignited the exportation and establishment of European cultures to the New World. Together with other disciplines like architecture, literature, theatrical (religious) staging and ornament making, art was

a tool for understanding the new. This conception of art as instrumental was reiterated with the ecumenical Council of Trent, held in three sessions between 1545 and 1563 by the Roman Catholic Church. It was the response to Martin Luther's publication, in 1517, of his ideas criticizing papal authority and its corruption, that ultimately led to the Reformation. It was a time loaded with poverty, warfare, religious and political persecution. Nonetheless, if we turn our attention to the cultural achievement of the early Modern era, it was also a time of the emergence of processes of aesthetic information. Artistic and scientific methods functioned as a means to build the principles of empirical investigation and knowledge – key features of the European Enlightenment.

The Council of Trent clarified the Roman Catholic Church's doctrine, strengthened the authority of the papacy, and redefined art not as storytelling but as the symbolic interpretation of Catholicism – all measures that provided the Church with a foundation for the Counter-Reformation.

The following two centuries witnessed a process of secularization of art (including an anti-symbolical approach) that crystallized in the French Revolution (1789–1799) and the possibility of enjoying art independently of social and cultural hierarchies (Enwezor 2003a). This process of secularization 'liberated' art from social constraints but also contributed – providing the cultural justifications – to the expansion of the Old World under the terms of colonization and imperialism. Traveller-reporters acting as historians, scientists and geographers systematically adopted art to serve the purpose of documenting landscapes, populations and facts. Between 1768 and 1776 Captain James Cook, in his exploration of the Pacific Ocean took artists with him in order to render as precise as possible the natural landscape and phenomena encountered in his three voyages. Naturalists Alexander von Humboldt and Aimee Bonpland wrote and illustrated a report on the physical aspects of Cuba, Central America and Mexico after a five-year journey from 1799 to 1804; the work was enthusiastically welcomed as a sort of second discovery of the New World. Both Turner (1834) and Constable (1836) on more than one occasion felt bound, through painting, to record man-made or natural scenes or events (Winston 1995). Artist Johann Moritz Rugendas, in his two journeys in Latin America between 1821 and 1847, produced more than 5000 paintings and drawings depicting nature, settlers, slaves, customs, cityscapes, village views, facts and chronicles (Catlin 1989: 49). These works, that operate between factual reporting and creative effort, established an idea of art and science that framed them as able to investigate and determine the understanding of natural and human phenomena. The descriptive function of art widened the idea of creativity as a source of reliable knowledge. This development towards a scientific or 'neutral' rendering of reality through art, which was the result of the European Enlightenment, probably marked a fundamental point in the development of the journalistic approach. This was also achieved thanks to the simultaneous development of the democratic tradition in European societies. As early as the end of 1800, art and literature were politicized in order to receive and re-distribute information, reports and

ideas that would otherwise not have been possible to channel: they were, in fact, re-distributing that which was in danger of being left outside the public debate (Jonsson 2004: 60).[1] Visual art, theatre and literature, under political circumstances of totalitarian regime or absolutist rule, first collected and then re-channelled dissenting opinions, and censored information as artworks. Art and literature movements of that time (for instance, Impressionism) help to identify a new class in society: the bourgeoisie citizens of the city who could suddenly afford to spend Sundays in the parks, buy paintings and distinguish themselves as noteworthy citizens with economic power. We could aptly consider the depiction and identification of this class as the first appearance of modern journalism by means of aesthetics. In those days the production of artworks was part of architecture, theatre and image development (in photography, but also the dawn of the moving image).

There is a parallel between the development of this scientific approach and that of Western democracies, slowly overpowering the former theocracies; this aspect of rationality eventually led to the social realism of the early twentieth century. The new cultural category of the everyday gained autonomy and aesthetic value through the paintings of proletarian life by of artists like Edouard Manet; or Charles Marville's urban photography. These artists helped to redefine, and code, the ordinary, ugly and everyday *as* the modern. The Russian Revolution in 1917 brought into stark focus the expanded notion of realism and the everyday, both politically and culturally; the working class was in (potential) control of both reality and its various representation, this latter conceived as an educational tool; and artists were expected to become co-workers with engineers and scientists in the production and organization of society (Roberts 1998). Journalistic techniques like archival research, interview, report and factual records became familiar among artists and authors with the dawn of the 'experimental' documentary film genre in the 1920s. Despite differences in political and ideological positions of the Russian avant-garde, Esfir Shub, Dziga Vertov, Sergey Eisenstein, Boris Arvatov, Sergey Tretyakov and other protagonists of that movement promoted the making of the world via the interaction of art and information. All of them film directors, editors and theorists, they proposed an idea of editing as a montage technique, not only to link scenes but rather to create a 'collision' of shots, in order to generate metaphors. For these artists to film did not simply mirror the world but actively produced an understanding of it; their approach was a special investigation of the world in order to change it, as Esfir Shub put it in 1927: 'The whole problem is what we must film now. As soon as that is clear to us, then the terminology won't matter – fiction or non-fiction' (Tretyakov et. al. 1971: 34).

Without making an encyclopaedic effort to embrace everything and everyone, I ought to mention at this point the work of two other key pre-WWII figures. The first is John Heartfield (real name Helmut Herzfeld), a self-defined 'press worker', who was one of the first artists to appropriate the method and rhetoric of mass media communication, which coincided with the Nazi propaganda machine. Working during the 1930s with photography and montage for different press journals and magazines, Heartfield

produced a mass of ironic work that commented on the Nazi regime and questioned its claims for truth. He considered the smallest fragment of the everyday to be more valuable than an artwork, in line with what Walter Benjamin (and playwrights Bertolt Brecht, Arvatov and Tretyakov) were insisting: the artist/photographer must provide a work, be able to break down the barrier between the artist as creator and the spectator as consumer. I will return to Brecht, Benjamin and their work later in the book. The second figure I ought to mention is Walker Evans, the photographer who has been attributed, back in 1935, with defining the distinction between the documentary as a form and the 'documentary style' – a definition that brings together document (the principle of objectivity) and art (the artistic interest). During the 1920s and '30s he documented the American Depression and produced highly aestheticized pictures of poverty and distress in urban and rural settings. However, Evans worked not only as photographer, but also as editor and writer for the magazine *Fortune*,[2] exploring the artistic medium in combination with the publishing context. Evans' photography elevated the everyday and the casual into a specific and permanent symbol, foregrounding the work of much of the journalistic reportage of our recent decades. His dry, almost detached pictures of train travellers of the New York underground, shot between 1939 and 1941 with a hidden camera have become famous as has the series depicting rural workers in the south regions of the States. Evans attempted not to pass judgement on the subjects or situations of the photograph, but let the viewer depict a world, which can only be imagined. He took photography not as an activity *per se*, but as the context of a research; for all these aspects – the viewer's active role, the artist's research and his multi-context approach – we can consider him a contemporary artist, according to the definition of aesthetic journalism.

…and some closer to the present

The Second World War represents a watershed due to the perceived urgency, in its aftermath, to re-think aesthetics at large. Artists (and not only artists) felt the urge to regain a 'reality' approach in reaction to the dominant abstraction and introspection, considered too implicated with recent history and dramatic events. If in America the mainstream abstract movement continued to flourish undisturbed by close dramatic events, in Europe there was a need to forego what had just happened on a social, political and ideological level. It was a matter of taking a step back, a necessary response that compelled young authors to search for the real and the authentic in many fields, from literature to theatre, neo-realist cinema to music and the visual arts. Significant cultural theories and practices have developed worldwide in the years between the end of the Second World War and the 1960s. Some of them had a strong theoretical background (like the Situationist International) or sourced their material directly from popular culture (graffiti, comics, experimental cinema, visual poetry). Other experiments combined different disciplines (like the groups generated by musicians such as John Cage or Pierre Henry), not to

mention the explosion of rock-and-roll and pop music. This fervour was caused by the acquisition of a new dimension for the body and the spirit, liberated from the social and moral obligations present before the war. This new 'state of mind' would climax in the social rebellion of 1968, and lead on to the late 1970s social crisis and acts of political terrorism (especially in Germany and Italy).

Post-WWII Western society was fully immersed in a sense of industrialization and modern life manifested in a renewed interest in urbanism (the city), advertising (the consumer) and media (the spectacle) that altogether shaped a new form of aesthetics; this, in turn, contributed to a new approach in the arts. We should read the artistic experiences of the 1950s and '60s through this lens. In fact, before this time art imagined the future; from this point on, the social almost literally provided material for art, which became a tool for the investigation of the living. As a single example, in the 1960s the film critic André Bazin promoted a theoretical discussion on the subject of the 'televised man'. What he wanted to discuss was the question of whether art should mirror the world or not; arguably, an inquiry still at the core of current artistic investigations. Back then, artists asked themselves why should art not take part in changing (for the better) one's life; if aesthetic practices were to be bound up in museums, to contemplate and celebrate

Situationist International (SI) is a political and artistic movement initiated in 1957 that wanted to abolish the notion of art as a specialized field, and convert it to a factor of everyday life. The German-Scandinavian fraction of the SI, in particular, believed in direct action, and sustained the idea that culture could prefigure different ways to organize life. The SI and its members, Guy Debord among others, heavily influenced cultural and political positions of later years, from the 1968's revolts to the punk rock scene in the 1970s; from street artists of the 1990s to net-hacker movements.

André Bazin, co-founder of the magazine *Cahiers du cinéma* in 1951, advocated for 'true continuity' in cinema making. In his view, the interpretation of a film should be left to the spectator, and the director should work through *mise en scène* rather than experimental editing. This was in total opposition to avant-garde film theory of the 1920s and 1930s (Eisenstein and Vertov), which instead emphasized how the cinema could be manipulative.

the sublime, how could they possibly have a meaning in life? The artist's work moved into the domain of capitalism (confronting, using or manipulating it), consumerism and popular culture; these new conditions for artistic production blurred the boundaries between art and life, and opened the way for art to be assimilated with any number of relationships with society's other 'structures' and with mass-media aesthetics. This change was pushed, almost simultaneously, from opposite positions in art: by celebrating certain media aesthetics (Andy Warhol, to name but one) and by questioning or subverting it (for example, Hans Haacke, Martha Rosler, Dan Graham, Grupo de artistas de vanguardia – all artists I will come back to later). Exposing the growing social and economical paradoxes of society through photo reportage and installations, which developed subsequently into film and documentary projects, these works were political since they unveiled hidden

agendas, gave voice to the excluded, and discussed alternative social models; in short, they provided a sort of multiplicity of interpretations of the world.

Art as self-documentation

During the 1960s, at the dawn of aesthetic journalism as we understand it now, some artists used journalistic methods not for a political commitment, but rather as an instrument of self-documentation within the artistic act. Self-documentation, in this case, stands for the maintenance, instruction and arrangement of the artistic activity, which is not oriented toward something outside of it; that is, it is not intended as the act of documenting an external reality. Artists used text, photography, audio and video interview, etc., to document the evanescent art practices centred on 'the context': performance art, Happenings, body art, land art and so on, up to 1990s relational art (Chapter 6). Documentary procedures absolved efficiently the function of witnessing what happened, contributing to the virtual survival of activities that we would otherwise not be able to assess today, being too ephemeral a reference. The evaluation, discussion and distribution of artworks accessible only through recorded material still constitutes critical reflection, even in the absence of the real event. To some extent those practices developed thanks to the possibility offered by techniques of documentation, which absolve the function of re-proposing something anew. There is also a second aspect of art as self-documentation. For many protagonists of body art, Happenings and performance, these techniques were a mirror by which to control their own actions, body and environment, and to determine the outcome. Performers like Gina Pane, Bruce Nauman and Orlan used documentary procedures not just to maintain their work's presence in time (which might have been planned), but also as a means to establish their presence in space (which was definitely planned). Other artists such as Luigi Ontani and Gilbert & George, via the use of art as self-documentation, invited the spectator into a dimension of desire or obsession. Others used the self-documenting process to address the referential character of the video image, pointing out the constructiveness of the image-making process; such are the 1970s works of Vito Acconci and Marinus Boezem. Although self-documentation was originally intended as a form of reporting actions, it soon developed a proper identity as a sort of archival activity for the survey of facts, people and narrative – and in this sense it functions as 'journalistic art'. Its principal feature is not (only) to retain memory and to make intangible events relevant to those who were not there, but also to constitute a concept of recording that is closer to 'maintaining' than documenting (Marra 2005: 259); that is, a system for retrieving information, re-circulation and reading anew.

Art as social criticism

Conversely, a number of artists were committed to raising social and political issues, and not in visual art alone: theatre and cinema was at the forefront, passing messages of

criticism to variously sized audiences. Key figures were Bertolt Brecht and his wife and collaborator Helene Weigel, who operated the post-WWI theatre company Berliner Ensemble. By exploring theatre as a forum for political ideas, they attempted to deliver a critical approach by way of reminding the spectator that the play or film is merely a representation of reality, not reality itself. In refusing the audience the possibility of being immersed in the spectacle, Brecht and Weigel maintained that the play be part of the real, thus always political. This method, coined *Verfremdung*, or 'emotional alienation', has had a huge influence on theatre makers like Dario Fo, Peter Brook, Pina Bausch and Caryl Churchill. And filmmakers such as Rainer Werner Fassbinder, Nagisa Oshima, Jean-Luc Godard and Lars Von Trier have adopted an aesthetic approach close to Brechtian self-reflectivity. However, it is probably due to the development of politically responsible street photography that aesthetic journalism became almost a genre in its own right. The idea of confronting society with a veracious mirror coincided with the introduction of portable 35mm cameras. By using photographic reportage, artists shaped the agenda of committed art; they took responsibility for divulging issues passed over by mainstream media, and representing them via a journalistic narrative, revealing meaning to an audience. I will briefly outline the work of three artists who adopted the journalistic approach at that time. Dan Graham, Martha Rosler and Hans Haacke – highly influential figures in contemporary art – all claimed a position as information providers. In some cases, this was directly communicated to the public (when a precise message was proposed); in other cases, it was only suggested (when the work was focused on the disclosure of procedures).

Dan Graham

Dan Graham (born 1942 in Urbana, Illinois) is an artist who looks into the relationship between architectural environments and those who inhabit them. In *Homes for America* (a title which, incidentally, resembles Walker Evans' 'Homes of Americans', produced for *Fortune* magazine in April 1946), Graham investigated in a photo-essay the development of prefabricated post-war houses, accompanying the pictures with a text in which he described them as a new form of urban living. The piece – first realized as a slide show for the exhibition 'Projected Art' at the Finch College Museum of Art in New York in 1966 – was originally meant to appear in a major popular magazine (of the *Esquire* ilk), and was designed like a sales catalogue of a real estate agency or a furniture outlet. Graham ultimately published the work in *Arts* magazine, December 1966 – January 1967, as a photo-essay titled 'Homes for America: Early 20th Century Possessable House to the Quasi-Discrete Cell of '66'. A few years before, another American artist, Ed Ruscha, produced a series of small artist's books, the first of which, *Twenty Six Gasoline Stations* (1962), was a serial survey of functional architecture in the American province. Inspired by his colleague's work, Graham travelled through New Jersey suburbia taking photographic images of serial housing in all their potential variations in style and colour. Like a photojournalist, he considered the medium of the magazine an adequate forum

for the presentation of his findings. In the repetition of the prefabricated house, he saw the serial mechanism of minimalism realized in social space, that is, situated outside the established art institution. Presenting a piece of journalism, Graham addressed questions such as anonymity and mass manufacture against the backdrop of the American dream, where – as Graham himself writes in the essay – 'contingencies such as mass production technologies and land use economics make the final decisions' (Swenson 2009) and the owner of a house 'is completely tangential to the product's completion' (Crow 2005: 155). In other words, the political and industrial programme considers the singular as a mere element of a mechanism. Graham uses, in combination with the pictures of houses, notes from builders' sales material, like colour combinations (as such: 1. White, 2. Moonstone Grey, 3. Nickel, 4. Seafoam Green, 5. Lawn Green, 6. Bamboo, 7. Coral Pink, 8. Colonial Red), and statistics on colours preferred by men and women. These details add social relevance to the theme investigated: instead of presenting the photojournalistic report by asking the reader to believe its authenticity, he disguises everything as 'authentic' commercial information, potentially involving the reader (though, in this case, still the reader of an art magazine) in a double activity: reading commercials and absorbing criticism. For this reason he saw his artwork legitimated only through its publication and circulation in magazines. Journalistic artworks like *Homes for America*, more than reflecting the author's point of view, hang between fact and fiction, the real and poetic; they question the orthodoxy of the image-text report itself.

Martha Rosler

Martha Rosler (born 1943 in New York) is an artist whose work is focused on everyday life and the public sphere. Media representation and the built environment are recurrent topics in her practice. Often involved in community related projects, she adopts journalistic-style investigation to turn attention to degraded urban environments, at the same time denying the capacity for that system of representation to transfer the reality depicted:

> Documentary, with its original muckraking associations, preceded the myth of journalistic objectivity and was partly strangled by it. [...] This mainstream documentary has achieved legitimacy and has a decidedly ritualistic character. It begins in glossy magazines and books, occasionally in newspapers, and becomes more expensive as it moves into art galleries and museums. [...] One can handle imagery by leaving it behind. (*It is them, not us.*) One may even, as a private person, support causes. (Rosler 1993: 303–306, original italics)

One of her best-known works is an installation project *The Bowery in Two Inadequate Descriptive Systems* (1974–1975). The piece is a series of documentation and artworks comprising 24 panels, each with one photograph of New York's Bowery neighbourhood, an area socially challenged by alcoholic abuse, accompanied by a list of the many terms for

an alcoholic. Rosler juxtaposed black-and-white images of the unpopulated storefronts in front of which alcoholics would often hang out, with short lists of terms for drunkenness, like: stewed, boiled, potted, corned, pickled, etc. The work, therefore, investigates the environment but, instead of offering the 'presence' of a depiction, it depicts its absence, shifting the focus from a critique of social inadequacy to a critique of media representation of that inadequacy. In fact, while the words, the environment and even the medium (photojournalism style) evoke the notion of alcohol abuse, all the frames are devoid of people. At the same time as paying homage to the cityscapes of Walker Evans, Rosler used the journalistic method of reportage but reversed it, in the attempt to increase the void of representation. In this case, her approach almost contradicted journalistic portraiture, since this would probably have represented human subjects in the pictures. (Though, honestly, we cannot assume what did not take place.) However, as the title suggests, the work reveals the impossibility for either descriptive systems (photo and text, direct metaphors for art and journalism) to grasp the complexity of the situation in a multifaceted reality. The two systems run along concurrently; no single descriptive model can appropriately portray what creates such compartments of urban isolation and life privation like that of Bowery in the 1970s. The only possible approach would be to try reading in between the lines of the means of representation, be that historical, cultural or sociological.

Hans Haacke

Hans Haacke (born 1936 in Cologne) is a conceptual artist concerned with systems and processes: from biological systems like animals, plants, water and wind to socio-political structures. His practice is an attempt to read these systems; for instance, the connection between art institutions and the wealthy, and the mechanisms of art patronage. The issue is still very relevant, as no single institution nowadays can avoid fundraising campaigns, often with the result that corporations and business magnates exert great influence in boardrooms. Haacke's early works dealt precisely with the networks of relations in a big international museum: in his piece *MOMA-Poll* (1970), part of an exhibition at the Museum of Modern Art in New York aptly titled 'Information', he solicited visitors to fill out a ballot given to them on entry to the museum. The ballot presented visitors with the following:

Question:

Would the fact that Governor Rockefeller has not denounced President Nixon's Indochina policy be a reason for you not to vote for him in November?

Answer:

If 'yes' please cast your ballot into the left box
If 'no' into the right box.

Ballots were dropped into either of two Plexiglas boxes, and the results were: [Yes] 68.7 per cent; [No] 31.3 per cent (Schiller 1989). At the time, Governor Nelson Rockefeller and his brother David Rockefeller were on the board of trustees of the museum. The purpose of the work was to raise awareness of socio-political connections that were not normally part of the museum experience. In another work of 1971, when Haacke was invited for a solo show at the Solomon R. Guggenheim Museum in New York, the piece *Shapolsky et al Manhattan Real Estate Holdings, a Real-Time Social System, as of May 1, 1971* consisted of 142 photographs of New York apartment buildings, two maps of New York's Lower East Side and Harlem, marked with properties, and six charts outlining business relations within the real-estate group. The work exposed the transactions of Harry Shapolsky's real-estate business between 1951 and 1971, with each photograph accompanied by text describing the location and the financial transactions that involved the depicted building. The museum's management deemed the work inappropriate and cancelled the show six weeks before the opening; Edward F Fry, the curator who backed the artist, was also dismissed. Haacke's research was conducted using journalistic methodology: it transferred the methods and technique of documentary filmmaking into a different medium, such as photo and text reportage. The Shapolsky business attracted his attention due to the fact that it owned more slum properties than any other estate owner in New York. The 'real-time social system' of the title was invisible to the public eye, yet entirely accessible through public records, which revealed how different properties were held by different names, all part of the same group.

Art as reporting

In the works described above, neither text nor images are primary, this being one of the reasons for their prevailing relevance in our time. None of them submitted totally to the aesthetic of the visual, retaining instead a significant aspect of journalistic reporting. On the other hand, a project like *Tucumán Arde* [*Tucumán Burns*], described below, connects the two aspects of art as social criticism and art as a form of reportage. It is possibly a prototype for all the subsequent artistic reportage seen in biennials and large-scale art exhibitions.

Grupo de artistas de vanguardia

The art collective Grupo de artistas de vanguardia organized *Tucumán Arde* in 1968 as part of a series of aesthetic works that aimed to denounce the cruelty of the Vietnam War and other social issues, not only by creating a relation between the artwork and the mass media, but also by attempting to effect political consequences through the work. The initial brief of the project was to examine the social and economic situation in the Argentinean province of Tucumán. The government, then led by the military dictator Juan Carlos Onganía, identified the region with the threat of leftist radicalism, and so initiated a 'neo-liberal revolution' during the 1960s, intervening in its agricultural structures. The resulting

privatization caused the closure of many small sugarcane factories, which produced unemployment to a large scale (more than 60.000 workers were put off work) and generated extreme social hardship. Tucumán faced impoverishment despite wealth; the (hidden) governmental agenda was to dismantle the workers union by dividing it into smaller units, also forcing the dissolution of families through the relocation of the workers' to other regions (Gramuglio and Rosa 1999). Grupo de artistas de vanguardia decided on a strategy of counter-information via over-information. The plan was to create an 'informational circuit' to prove the distortion inherent in mass-media representation of conflicts in the region. Mainstream media were complicit in silencing the problem caused by the proposed closure of the sugar refineries and the relocation of families; they were also creating a misleading image of economical recuperation via a façade-like plan that indicated new hypothetical industries in the area. Artists invited intellectuals and sociologists to collaborate in this action of counter-information; Eduardo Favario, Aldo Bortolotti, Rubén Naranjo, Noemí Escandell, Emilio Ghilioni, Graciela Carnevale and Norberto Púzzolo travelled to the province, to be joined soon after by Carlos Schork, Oscar Pidwustua (filmmakers) and Beatriz Balbé. They set out to find out the social and political reality of the region, to witness and gather these facts, and verify the consistency of the governmental claim, both regarding the sugar industry and the proposed industrial plan. Working as social researchers, they resorted to photographs, interviews, films and other documentary media placed in the public sphere to show the falseness of official propaganda. The material was then exhibited via a multiform audiovisual montage in the Workers' Union Hall, first in Rosario and then in Buenos Aires, where military pressure enforced the closure of the exhibition, despite the artists' effort to camouflage it as 'First Avant Garde Biennial' to avoid censorship. Needless to say, the artistic operation was conceived as a way to hide the real motives of the exhibition, namely, the denunciation of the real situation in Tucumán in a moment when political acts or meetings were forbidden. The military regime proved to be too strong: the planned tour to other centres of the Workers' Union and students' halls throughout Argentina did not take place. Also, the planned publication of all the research material and a final evaluation of the project was never produced due to the group's dissolution soon after.[3]

Art as an emergent form of journalism became the paradigm for 'committed' artists and collectives during the 1990s, particularly with the large-scale exhibition documenta X in Kassel (1997), curated by Catherine David (with Jean-Francois Chevrier), which provided an extensive theoretical framework and production support for the artists working with journalistic methodology. In this circumstance, one of the issues at stake was the artistic quality of documents. The photographic reportage assumed the role of a system of orientation, connecting the different areas of the exhibition: Surfaces & Territories, Cities & Networks, Groups & Interpretation, In & Out. (The names eloquently show the arts' embrace of social and geographical matters.) Using the exhibition as a form of public

conversation, David invited artists using text, photography and video to deliver information from locations 'uncovered' by mainstream media. The exhibition encouraged the idea that the contemporary art scene is able to facilitate socially related investigation, indirectly claiming its un-attachedness with commercial interests or ideological agendas, and presenting a concept of documentary and reportage where the evidence of facts is matched by its imaginative re-writing. The following Documenta 11 in 2002 (mentioned in Chapter 2; artistic director Okwui Enwezor, with the collaboration of five co-curators), contained even more reportage on neglect of the natural environment, economic and social dispossession, ideological and military repression. In response to this attitude, and even with the recognition of the social commitment and the exceptional nature of the exhibition concept, some critics underlined that merely acknowledging the constant presence of global traumas – like images in magazines – does not necessarily speak 'for' (or should we rather say 'with'?) them:

> You see a lot of work that could be described as "good for you" but little that stimulates the imagination. […] Seeing so many documentaries of the world's horrors ultimately has a diminished impact, like watching too much CNN. […] Though the effort is admirable, Documenta 11's concept of political art as documentary does not encompass a reflexive approach to the exhibition itself. (Meyer 2002)[4]

It is interesting to read what theorist Roland Barthes wrote in 1980 about the format of reportage: although he was referring to the photographic medium, his considerations may as well work for today's video formats. Barthes believed that art should be critical and interrogate the world, rather than seek to explain it. In his book on photography he stated that the photos that constitute a reportage are able to traumatize, but not 'move' the viewer, that is: photo-reportage as a critical medium is usually received by its audience, but rarely functions as reference for in-depth discussion or consequential action (Barthes 1981). His critique largely explains our anaesthetization regarding images of war reportage in mainstream media. When press, television and the internet (as well as relevant visual art or cinema) present a stark depiction of a conflict, however gruesome and shocking the images might be, we contemplate it for the duration of a glance, and rarely retain it. In this sense, war reportage and pornographic pictures have something in common: the homogeneous effect produced by a continuum of image over-exposure leaves us shocked or disgusted or desirous of more (according to one's own taste), but never interests us to the point of wanting to really *see*. As demonstrated by the examples of art of the 1960s and the '70s, this society is involved in a constant search for strategies of authenticity as a source of real experience and assessment for the quality of existence. We observe 'life out there' at a certain distance, as if through the viewfinder of a photographic or video camera: a longing for authenticity (Chapter 3) difficult to experience, given the media's increasing control of our first-hand experience. In the current situation, no space other

than art (venues, programmes, funding bodies, producers and receivers) can sustain the effort to counter this control; and, as long as they do not convert to a sort of 'political news service' for the art circuit, this is a potential still relatively unexplored.

Notes

1. Jonsson in his text quotes as historical references the work by Karl Kautsky and Franz Mehring, see Further Reading.
2. David Campany, *Walker Evans' pages*, paper for the conference 'The Photobook' at Birkbeck College, University of London, 3–4 April 2009. Organized by Patrizia Di Bello, Colette Wilson and Shamoon Zamir.
3. My thanks to Graciela Carnevale for the first-hand information in a conversation and subsequent email exchange April–June 2009.
4. For other critical views on *Documenta 11* see in Further Reading the works by Sylvester Okwunodu Ogbechie, Eleanor Heartney, Matthew Higgs and Kim Levin.

Further Reading

Arvatov, Boris (1972), *Kunst und Produktion*, Munich: Carl Hanser Verlag.

Bazin, Andre (1967), *What is Cinema?* (trans. H. Gray), Berkeley and Los Angeles: University of California Press.

Bazin, Andre (1971), *What is Cinema? Vol. 2* (trans. H. Gray), Berkeley and Los Angeles: University of California Press.

Crow, E. Thomas (1996), 'The simple life: Pastoralism and the persistence of genre in recent art', in *Modern Art in the Common Culture*, pp. 173–211, New Haven and London: Yale University Press. First published in *October*, Vol. 63, Winter 1993, pp. 41–67.

Eisenstein, Sergey M. (1949), *Film Form: Essays in Film Theory* (trans. Jay Leida), New York: Harcourt-Brace.

Heartney, Eleanor (2002), 'A 600-hour Documenta', in *Art in America*, 90 (9), pp. 86–95.

Higgs, Matthew (2002), "Same Old Same Old" in Higgs, Matthew; Holert, Tom; Meyer, James and Nochlin, Linda, 'Platform Muse: Documenta 11', in *Artforum International*, vol. 41 (1), September, pp. 166–167.

Kautsky, Karl (1889), *Die Klassengegensätze von 1789*, Stuttgart: NN.

Levin, Kim (2002), 'The CNN Documenta: Art in an international state of emergency', in *The Village Voice*, vol. 47, July 3–9, p. 27.

Leyda, Jay (1960), *Kino: A History of Russian and Soviet Film*, London: Allen and Unwin.

Mehring, Franz (1967), *Die Lessing-Legende,* Berlin: Dietz (first published 1894).

Ogbechie, Sylvester Okwunodu (2005), 'Ordering the universe: Documenta 11 and the apotheosis of the occidental gaze', in *Art Journal*, 64 (1), Spring, pp. 80–89.

Raunig, Gerald (2007), *Art and Revolution: Transversal Activism in the Long Twentieth Century* (trans. Aileen Derieg), Los Angeles: Semiotext(e) (first published in German, 2005).

Chapter 5

HOW shall we Read Aesthetic Journalism?

Aesthetic journalism conveys other forms of interpretation of the world, distinct from that of art and traditional journalism. In this chapter, I would like to propose a theoretical view – some references that might become useful the next time we encounter 'journalistic art'. Let me start from this point: the journalistic form of knowledge is *one* type of knowledge, but not the only one. As mentioned in Chapter 2, we tend to think in these terms since it has become the prominent, universally accepted approach (Scannell 1996). The list of incursions of journalistic methods into different areas goes well beyond our preoccupation with art, but it is this latter that interests me, and for a specific reason. I need to make a little excursion here. Throughout this book, artistic production is seen in relation to the economic, social and political context, and not as an autonomous activity for intellectual or aesthetic pleasure – a concept born in the eighteenth century under the ideal of equal opportunity for all subjects. Since then, the idea of art as a self-sufficient field has been cemented in our culture, until the journalistic turn of the end of the twentieth century. We have seen that with documenta X (1997) and Documenta 11 (2002), contemporary art came to terms with its self-sufficient status in order to challenge 'a surprisingly conservative notion of the disinterestedness of art in its relation with social life' (Enwezor 2004, in Nash 2008: 121, footnote 8). These exhibitions questioned power relations by using journalistic art as a critical instrument for investigation. The idea was less about documentary filmmaking and artistic practices claiming to convey universal truth, than about denouncing the claim to universal truth staked by mainstream journalism. To come full circle, and close my brief detour, the reason why I think it is important to discuss journalism in relation to art is that I have a hypothesis to test. I advance the idea that, with the art world's fervent grip of the journalistic approach, the production of truths (the question: what is truth?) shifted, and is shifting, from the domain of news media to the territory of art. If this holds true, the next question would be: does aesthetic journalism function as an instrument to provide orientation within the flux of information?

Reading reality

The journalistic position in art responds to an urgency felt by artists and video makers to foreground topics that are absent from mass-media information; it is also part of a tendency to use journalism and documentary methods to persuade the audience on certain issues. With respect to the latter perspective, artists tend to attribute 'ethical' value to this particular form of representation, and to exploit its position of power. This is close

to Marshall McLuhan's famous 'the medium is the message' (McLuhan 1994: 7), the catchphrase that implies how new *forms* of media (rather than content) change the perception of society, and move from a linear way of understanding the world (first oral, then written narratives) to a constant and contradictory flux of signs (which are seen and interpreted). The medium that actually carries the content is essentially devoid of any content: the important aspect is not the information but the forms of communication that deliver it. The medium, and not its content, is the element that influences our perceptions and social relations. Here, we can consider the practice as resulting from the interaction of journalism and art as the medium under scrutiny. The bond between aesthetics and media has been studied for a long time, particularly in the social sciences. Social anthropologist Clifford Geertz, for instance, proposed considering culture (in this case, art) being like a map; functioning both as a *model of* – describing phenomena, processes and events – and a *model for*, providing the instructions to build a reality (Geertz 2002). Given that art traditionally takes its point of view from a clear-cut separation between the virtual (in forms of representation like painting, music or film) and the real, does the value of journalistic art reside within the format itself, as in formalist art, or in the fact that it represents a particular reality? To use a journalistic approach means to adopt not a 'more real' structure of representation, but a more efficient one for the development of narrative. Facts become convincing evidence when inserted in a narrative that is familiar to the viewer (Ekstrom 2002: 273; see Chapter 2) and, as we have amply seen, artists and documentary makers investigate the real with the spirit of 'assault' journalists. The uncritical re-allocation of journalism in the aesthetic sphere has produced the paradox we discussed earlier (Chapter 3): a significant number of artists, who work with journalistic methods, merely reproduce the same mechanisms of information adopted by mass media, without questioning their means of production. They pursue an alternative viewpoint for what is represented, but achieve only a sort of 'inverse' propaganda for this or that cause. Undoubtedly, we owe respect to counter-information activities, especially those born within specific political or social conditions, such as dictatorship or an extremely regimented society. However, I would argue that relying on the idea of 'passing' journalistic knowledge to another type of audience, like the artistic one, does not raise awareness of the mechanisms of information-making, and does not help to constitute critical principles for the future.

Geertz's work focused on the role of thought and symbols in society. Symbols guide action; culture, being a system of 'conceptions expressed in symbolic forms', makes the world understandable.

To better grasp what is at stake, I take on board the work of three thinkers, each providing their own bit of this theoretical jigsaw. First, let us question what we really see, and what we assume we are seeing. The documents and journalistic pieces of evidence that are consumed daily, besides making the point of their authors, represent

a model for what theorist Kaja Silverman called the 'cultural screen' (Silverman 1996). This is the repertoire of images that are given to us in a certain historical moment and culture (which here means our opinions, beliefs and association of thoughts). Building upon the work of psychoanalyst Jacques Lacan, Silverman advances the idea that we can only experience our reality as a particular version of the real, intended as a set of practices and relations; this certain side of the world is constructed, for the most, by the screen. The way we look at the world and the way we are seen by others is always mediated by images. TV pictures do not produce 'culture' but establish a strict relationship between what we see and what we know: they form the condition for us to see (Becker 2004).[1] As language pre-figures our coming into the world, and allows us to interpret signs, a catalogue of images similarly provides us with possibilities and limitations to understand the world. The screen defines our idea of others, but also of ourselves, since we incorporate our expectations in the way we present ourselves. Now, why is this idea of the screen so important? For one thing, because it means that by changing the collection of images, and bringing new material into circulation, we change the way we assess people and circumstances. In addition, because there are predominant ways of seeing and evaluating, this provokes a sort of 'fiction' in which we live, that is, our accessible version of the world. These predominant ways are widely present and circulating as stereotyped images of immigrants and asylum seekers on television and in the press, for instance. Media journalism plays a major role in establishing this predominance. Silverman goes so far as to say that in a given culture what is ideologically taken for reality is in actual fact a 'dominant fiction' (Silverman 1996: 178). An example is the way in which the 'eyewitness news' (i.e. live-stream from mobile cameras) has become the model for objective truth during recent war reportages and terror attacks. The instantaneity of these devices constructs 'an impression of significant unfolding events with the reporter as eyewitness, but at the expense of context, detachment and maybe accuracy' (Robinson, Brown, Goddard and Parry 2005: 952). These mechanisms of image making are responsible for our association of knowledge with photography, video and seeing in general.[2] A second theorist, David Natharius, proposes two main axioms regarding visual communication: the first, 'the more we know the more we see', implies that we can multiply the meanings we can make from our visual impressions. The second, 'what is not seen is as important as what is seen', proposes that we should always ask what television, magazines and newspapers are *not* showing us, and how they have altered the images they *are* showing us. According to this, since we mistakenly believe that visual perception is the most accurate of our

Jacques Lacan worked on Freudian concepts like the ego, the unconscious, the castration complex and the centrality of language in shaping subjects. His theory of the 'mirror stage' takes the moment in which the child recognizes themselves in the mirror as the permanent model for the subjectivity of the adult, who is 'obsessed' by their own image.

senses, we forget that we have been taught to 'see' – as we have been taught to read and write – and that 'we do not know what we are seeing until we have learned what it is we are seeing' (Natharius 2004: 242). What we take for truth is, in fact, what best fits our cultural screen. Finally, a third author and theorist, Susan Sontag, tackles the issue from another angle. She proposes that photography (I read film and video as an extension of this) is a medium so powerful that it imbues real things with the quality of the images that reproduce them (Sontag 1977). She draws a political consequence from this: since photography embodies two essential features – the spectacle (for the mass) and surveillance (for the government) – it provides the perfect tool for a dominant ideology. Her conclusion is in line with both Silverman and Natharius, although starting from a different approach.

What can we learn from all this? Today we have a multitude of perspectives rather than a universal truth. The previously posed question 'could that be true?' has to be reframed in a more appropriate way, asking ourselves under what conditions this can be true (Žižek 2002). It is crucial to negotiate anew each time the conditions in which these stories are to be told. The difficulty to assess truth-telling depends not only on the number of sources, but also (or perhaps, rather) on the way information is organized; it does not matter what actually happened, but what people are made to think what happened (Foucault 1980). In our recent history media information processes have increasingly influenced the way we live: in 1951 a photo reportage on famine in Bihar (India) by Werner Bischof for *Life* magazine influenced the US government's decision to appropriate a surplus of wheat (136 million tons) to alleviate the disaster. In the case of both the Bosnian War and the Gulf War, documentary reports on US and European televisions and newspapers provoked military intervention, mass panic and humanitarian relief regardless of the fact that accounts might have lacked correspondence with factual truth (Virilio 2004). The examples could go on forever, as the ability to read reality goes hand in hand with the possibility to construct it.

Constructing reality

Two prominent figures of modern philosophy and critical thinking, Walter Benjamin and Michel Foucault, based their studies on the notion that a document *constructs* a historical scenario, rather than merely representing it (Chapter 3). For centuries documents were the expression of powerful people who controlled the means of political, economical and social structures. The work of Benjamin, who in a certain sense was the observer of 'the becoming' more than of 'the being', attempts to understand when, and how, things become the way they are, and how they are about to transform into something else. He consistently worked on the idea that accepted views are formed by the organization of documents in systems of truths that are established no matter how verifiable or real the content may be. In the words of historian Hayden White historiography is less a discovery of events and

objects than their construction through narratives (Steyerl 2005). To re-insert documents into other frameworks (i.e. art) without questioning their status, in an attempt to demonstrate their corruption, one might end up proposing another authoritarian reading, like the inverse propaganda mentioned earlier. An artist who tries to undermine an accepted truth, but does not consider what their documents produce, fails in the first instance to change the viewer's perception of document and truth itself. On his part, the work of Foucault addresses the fact that a subject is able to tell one truth about his- or herself, only if they are allowed to do so within certain power relations. The subject, in other words, is formed by the rules that allow them to speak, and that they will exert on others. Modern societies constantly develop these rules into authoritative structures such as the tribunal, the hospital, the professional order, the classroom, etc., to control the activities within what is considered truth and knowledge: a *truth-regime*. For Foucault, history is like a sequence of fictions, as truths change according to power structures, just as when the media coverage of war and terrorism is 'fictionalized'. Truth is a function of language (that is, culture), which

> Benjamin's work is centred on the belief that many aspects of the past and the present cannot be understood within what he called the 'grand narrative'. Examples of these intellectual and practical structures are history-making or logic-based reasoning.

> Foucault's concern has been the question of telling the truth: how ideas considered permanent truths about human nature and society change in the course of history. He conducted his research via analyses on madness, crime and punishment, and sexuality.

is created by humans; indeed all truths are created by humans. Every culture constructs its own version of what is true (and what is not), and the system to recognize it. "'Truth' is linked in a circular relation with systems of power which produce and sustain it, and to effects of power which it induces and which extend it. A "regime" of truth' (Foucault 1980: 133). A journalistic procedure such as the interview is an example of how an institutionalized activity produces knowledge, which in turn sustains: a) the concept of truth; and b) the very idea of the institute itself (Heritage and Greatbatch 1991). In this case, the authority of journalism *produces* knowledge, it is not itself knowledge. Many other mechanisms of this kind are at play in journalism, documentary and cultural production in general, like the twofold gesture of image-exposure and caption-explaining adopted by visual representation.[3] With regard to this theorist Bruno Latour brought forward the similitude between the place of the viewer in front of a documentary film and a scientific instrument *being* an inscription device: 'we are attending an "audio-visual" spectacle. There is a visual set of inscriptions produced by the instrument and a verbal commentary uttered by the scientist' (Latour 1987: 71, in Winston 1995: 136). As viewers, we judge and evaluate a representation against the backdrop of preconceived ideas we hold on the subject matter. Sometimes we do not even need a caption for an image to be self-sufficient; its own status as a repertoire element is sufficient to pass meaning (Bangma 2005).

Artists who use photo reportage, non-fiction filmmaking and archive-style installation often aim to inform in a realistic manner, with 'a sense of spontaneity in the footage, and an interest in banal scenes from everyday life' (Rehberg 2005). Even with archival construction, which can include fictional archive, combinations of found and new material and the drawing of new meaning from a combination of personal memory, association and imagination, the incorporation of the 'concept archive' itself has much to do with a sense of documentary, the witnessing of the past or evidence of the present.[4] Art's claim to be outside the existing world (in terms of denunciation) is questionable, especially if we compare an artistic act with a political one: they are both 'an arrangement of words, a montage of gestures, an occupation of spaces' (Rancière 2007b: 264). In fact, artistic and political movements share a history of similar tactics in order to achieve a form of public presence and to discuss their presence in society.[5] If artistic, political or journalistic manifestations are equivalent in their structure, what appears as knowledge (awareness of facts and situations) is only knowable through the practices that we use and are familiar with: this position is not outside the existing world, but embedded in it. An art exhibition can be transformed into a vast journalistic report or a political declaration, with the aim 'to make the world happen' (Raunig 2005: 96–97). However, in order to make that world happen one has to make clear one's own position in relation to the matter of investigation, exposing the grounds for working on the subject, and what they might gain from it. There is no reason why a viewer should accept more trustfully a journalistic reportage than an artwork; but this is also valid the other way around. I am not suggesting here that journalism is the same thing as art; they differ in essence, the former being a coded method, the latter a practice that constantly questions itself and its means. Whereas in art (and fiction in general) one adds to reality to construct a possible truth, in journalism (and documentary) one detracts from reality in order to represent truth only by a particular (and re-shuffled) segment of it, out of the continuum of life.[6] What I advocate is that an artist who works with journalistic forms and methods is *not* outside of the process of truth-making. As mentioned in Chapter 2, we require from both art and journalism a form to express our lived experience that reflects reality both in content and aesthetics.

Subjectivity at play

If we cannot dissociate the act of reading reality from that of constructing it, perhaps it is time to reverse the process, and simply accept the uncertainty of representation as the core element of *any* representation of the real (Steyerl 2007). It is the same as when we watch a live TV programme broadcast from a battlefield, where a journalist is capturing images with his or her mobile-phone camera onboard a moving vehicle: it is quite possible, actually, not to see anything but blurred pixels. One thing that an aesthetic approach to information could provide is the transparency of the failures of the

representational system, whether artistic or of the media involved. The comprehension of facts is based on one's active understanding of the world, rather than taking its appearance for granted. We cannot overcome the difference between the representational system and the event we try to designate with it. What can be done, though, is to ensure that the viewer is able to constantly analyse the relationship between the 'real event' and its representation. We could consider the different environments in which aesthetic journalism is at work (Chapter 3) as 'visualizations' of such attempts by individuals to resist truth-constructions, or to make new ones. These actions of individual or collective interpretation and production of truth reverse the idea of truth-regime, undermining the conviction that truth is only regimented in one direction. These efforts show that there is no main situation to challenge, but rather a matrix of different conditions to consider, as Foucault suggests by stressing the point that truth is always an unstable concept, and its effects, therefore, are unpredictable. On this point, his work challenges important theoretical analysis of the last century, such as the idea of a 'culture industry' developed by the Frankfurt School (a theory interesting to re-evaluate in relation to current media journalism and documentarism), and Antonio Gramsci's analysis of the hegemonic position of the ruling class in societies. Instead, Foucault advances the idea of power as a force at work throughout society, which leaves no room for rebellion or revolt, and insists that ultimately truth, on an individual level, is a personal interpretation of knowledge (Foucault 1988), and there is always the possibility of another outcome, different from that which has been orchestrated.[7] This argument finds parallels in the writing of thinkers such as Umberto Eco and Jacques Derrida (see next pages), and also in Jacques Rancière's idea of the 'emancipated spectator': the possibility to read artworks and documents in ways other than that planned by the author. In aesthetic journalism the artist negotiates what is supposed to be represented directly to the viewer, and does not

The 1950s Frankfurt School was a movement within critical theory and social research. Its members were influential intellectuals like Max Horkheimer, Theodor W Adorno, Herbert Marcuse, Erich Fromm. In particular, Adorno and Horkheimer defined the 'culture industry' – a concept defined by studying the combined effects of radio and cinema – as an instrument of mass deception, a pleasure mechanism that prevented people from seeing their place within society and making their domination acceptable.

The work of the writer and politician Antonio Gramsci was concerned with the importance of culture. He worked around the idea that to attain power, a class has to achieve first cultural hegemony; as a result, his analyses emphasized the difficulty of actually changing industrialized society, since the dominant class does not exert only a political or military power, but also an intellectual and cultural hegemony.

rely on the overview – this already being provided by traditional journalism. What is accessible for the viewer is not a general image of the world, but rather the specific, conscious position of the author regarding the subject matter, and its relation to the

viewer. We, as audience, are invited to think, make connections and solve enigmas represented in the artwork for ourselves, instead of relying on the author to explain. As Rancière summarized, 'an art is emancipated and emancipating when it renounces the authority of the imposed message, the target audience, and the univocal mode of explicating the world, when, in other words, it stops wanting to emancipate us' (Rancière 2007b: 258).

What you have read in this chapter, concerning the form of aesthetic journalism (via the work of the artist), and the context in which it is received (via the position of the viewer), seems to advocate the idea that mental constructions of events are more effective than factual documentation and transcriptions. In this regard, it is crucial to bear in mind the performative aspect of the spectator's reading or seeing. I borrow the concept from a few theorists who have examined this closely. Jacques Derrida wrote at the beginning of the 1970s that the acts of speaking and showing are both 'performative acts'; that is, they are operations that galvanise a movement outside of the self, transform a situation and bring forth consequences that are not necessarily those predicted by the author of the speech or show (Derrida 1982). Mieke Bal, on another side, stresses that any aspect of knowledge is not simply received, but also performed. What becomes known and what remains unknown is dependent on the culture and the intention of who is 'performing'. A work of art (although this concept is extendable to representation in general) requires the participation of the other party in the production of meaning: the study's subject, the production partner or the audience (Bal 2003). To deny or downsize the importance implicit in the act of observing, and consequently to select, compare and interpret anew, would mean to deny a basic mode of the human being. And Umberto Eco, in his 1962 text *The Poetics of the Open Work*, writes that 'the author offers the interpreter, the performer, the addressee a work *to be completed*' (Eco 1979: 62, original italics). Further along, in the same text:

> *Every* work of art, even though it is produced by following an explicit or implicit poetics of necessity, is effectively open to a virtually unlimited range of possible readings, each of which causes the work to acquire new vitality in terms of one particular taste, or perspective, or personal *performance.* (Eco 1979: 63, original italics)

If we apply the idea of the open work to aesthetic journalism, what we see is that even images produced under the dramatic need to testify what has been left out (like Alfredo Jaar's account of Rwanda as discussed in the next chapter) are subject to 'completion' by the viewer. In short, as Winston (1995) points out in relation to documentary practice, the basis from which to analyse the matter has shifted from representation (where nothing can be guaranteed) to reception (where there is no such need). The significance of aesthetic journalism today is shot through with the idea that we, as spectators, need to

be aware of the distance from the proposed subject, and from the author who proposes it. We must be aware of our capacity to interpret what we see, touch and hear, translating others' ideas into our own.

Notes

1. Becker acknowledges Bal, Mieke (2003), 'Visual essentialism and the object of visual culture', in *Journal of Visual Culture*, Vol. 2 (1), pp. 5–32.
2. Other studies discussing seeing as the principal knowledge-producer include Michel Foucault's *Discipline and Punish* (1977), Hal Foster's *Vision and Visuality* (1988), Jonathan Crary's *Techniques of the Observer* (1990), and John Hartley's *The Politics of Pictures* (1992), see Further Reading.
3. On the mechanism image-text, see in Further Reading the referenced texts of Fatimah Tobing Rony's *The Third Eye*, 1996, p. 45, Mieke Bal's *Double Exposure*, 1996, and in Bibliography, Bruno Latour's *Science in Action*, 1987, p. 71.
4. On the notion of the archive bearing relation to the documentary and the evidence of things, see in Further Reading Jane Connarty's 'Introduction' in *Ghosting: The Role of the Archive within Contemporary Artists' Film and Video* (2006).
5. On the relationship between artistic and political movements, see in Bibliography the work of Anna Schober: *Ironie, Montage, Verfremdung. Ästhetische Taktiken und die politische Gestalt der Demokratie*. In her analyses, Schober highlights that Dada slogans were adopted by French trade unions for their leaflets at the beginning of the 1900s; strategies for the 'articulation of resistance' against political ideologies were embraced by the Fluxus and Expanded Cinema movements in the 1960s; not to mention the anti-globalization currents such as Culture Jam or the Italian movement Tute Bianche in the 1990s. In an interesting twist, whereas in the early twentieth century artistic groups became politicized, supporting the political causes of their time via aesthetic means, later the political movements adopted aesthetic strategies as their distinguishing feature.
6. See 'Cinema come filosofia', round table with Giacomo Marramao, Stefano Velotti, Pietro Montani, Umberto Curi, Bernard Stiegler and Edoardo Bruno at the Philosophy Festival of Rome, 11–14 May 2006, in *MicroMega: Almanacco del Cinema Italiano*, Nr. 7/2006, pp. 93–116.
7. As an example, a technological surveillance device such as the CCTV camera has been re-appropriated by practices of inverse surveillance (also known as *sousveillance*), which question its use by government agencies and corporations (see in Further Reading the text by Mann, Nolan and Wellmann, 2003). Sousveillance is a form of inquiry based on the monitoring and analysis of surveillance systems, using devices like wearable wireless webcams. Initiated by activists as a form of personal legal protection, inverse surveillance has reached broader layers of the population as in Copwatch, a network of US and Canadian groups that monitor police activity and educate the public about police misconduct.

Further Reading

Adorno, Theodor and Horkheimer, Max (1995), 'The culture industry: Enlightenment as mass deception', in Curran, James; Gurevitch, Michael; and Woolacott, Jane, eds., *Mass Communication and Society*, pp. 349–83, London: Edward Arnold. First published in 1944.

Bal, Mieke (1996), *Double Exposure: The Subject of Cultural Analysis*, New York and London: Routledge.

Benjamin, Walter (1969), *Illuminations* (trans. Harry Zhon), New York: Schocken Books.

Benjamin, Walter (1972), 'A short history of photography', in *Screen*, 13(1), pp. 5–26. First published in *The Literarische Welt*, 1931.

Benjamin, Walter (2002), 'The work of art in the age of its technological reproducibility, in *Walter Benjamin: Selected Writings, Vol. 3: 1935–1938* (trans. Edmund Jephcott, Howard Eiland, et al.), pp. 101–133, Cambridge, MA: Harvard University Press. First published in 1936 as *The Work of Art in the Age of Mechanical Reproduction*, (trans. A. Blunden 1998), http://www.marxists.org/reference/subject/philosophy/works/ge/benjamin.htm. Accessed 30 December 2007.

Connarty, Jane (2006), 'Introduction', in Connarty, Jane; Lanyon, Josephine, eds., *Ghosting: The role of the Archive within Contemporary Artists' Film and Video*, pp. 6–11, Bristol: Picture This Moving Image.

Connolly, William E. (2002), *Neuropolitics Thinking, Culture, Speed*, Minneapolis: University of Minnesota Press.

Crary, Jonathan (1990), *Techniques of the Observer: On Vision and Modernity in the Nineteenth Century*, Cambridge, Mass: MIT Press.

de Certeau, Michel (1984), *The Practice of Everyday Life*, Berkeley: University of California Press.

Deleuze, Gilles (1992), 'Postscript on the societies of control'(trans. M. Joughin), in *October*, Vol. 59, pp. 3–7. The text was first published in French in *L'autre Journal*, 1, 1990.

Demos, T.J. (2006a), 'Out of Beirut', in *Artforum International*, Vol. 45 (2), October, pp. 234–238, http://findarticles.com/p/articles/mi_m0268/is_2_45/ai_n20524958/print. Accessed 19 April 2008.

Derrida, Jacques (1995), *Archive Fever* (trans. Eric Prenowitz), Chicago and London: University of Chicago Press.

Didi-Huberman, Georges (2007), *Bilder trotz allem* (trans. Peter Geimer), Munich: Wilhelm Fink Verlag.

Didi-Huberman, Georges (2002), 'Bilder trotz allem. Über ein Stück Film, das der Hölle entrissen wurde', unpublished text for lecture at Akademie der Bildenden Künste Wien, 14 December 2002, Vienna: Ed. Akademie der Bildenden Künste.

Foster, Hal, ed. (1988), *Vision and Visuality*, Seattle: Dia Art Foundation.

Foucault, Michel (1995), *Discipline and Punish: the Birth of the Prison* (trans. Alan Sheridan), New York: Vintage Books. First published 1977.

Foucault, Michel (2007), 'Subjectivity and truth', in Lotringer, Sylvère, ed., *The Politics of Truth* (trans. Lisa Hochroth and Catherine Porter), pp. 171–198, Los Angeles: Semiotext(e).

Geimer, Peter (2003), 'Bilder trotz allem. Didi-Huberman über Fotografien aus Auschwitz', in *Süddeutsche Zeitung*, 16 June 2003.

Gramsci, Antonio (1988), *A Gramsci Reader: Selected Writings, 1916–1935*, Forgas, David, ed., London: Lawrence and Whishart.

Hartley, John (1992), *The Politics of Pictures*, London: Routledge.

Lacan, Jacques (1977), *Écrits: A Selection* (trans. by Alan Sheridan), New York: W.W. Norton & Co. See also revised version (trans. by Bruce Fink), 2002.

Latour, Bruno (1990), 'Drawing things together', in Lynch, Michael and Woolgar, Steve, eds., *Representation in Scientific Practice*, Cambridge, Mass: MIT Press, pp. 19–68.

Latour, Bruno (1998), 'How to be iconophilic in art, science, and religion?', in Jones, Caroline A. and Galison, eds., *Picturing Science, Producing Art*, New York and London: Routledge, pp. 418–440, http://www.bruno-latour.fr/articles/article/066.html. Accessed 16 June 2009.

Levine, George Lewis, ed. (1993), *Realism and Representation. Essays on the Problem of Realism in Relation to Science, Literature and Culture*, Madison: University of Wisconsin Press.

Mann, Steve; Nolan, Jason and Wellman, Barry (2003), 'Sousveillance: Inventing and using wearable computing devices for data collection in surveillance environments', in *Surveillance & Society*, 1(3), pp. 331–355, http://www.surveillance-and-society.org/articles1(3)/sousveillance.pdf. Accessed 6 September 2008.

Nash, Mark (2004), 'Experiments with Truth: The Documentary Turn,' in Nash, Mark, ed., *Experiments with Truth* exhibition catalogue, Philadelphia: Fabric Workshop and Museum.

Tobing Rony, Fatimah (1996), *The Third Eye: Race, Cinema, and Ethnographic Spectacle*, Durham, NC: Duke University Press.

Chapter 6

WHO produces Aesthetic Journalism Today? From Which Position?

This book attempts to grasp an emergent mode of journalism through art, which I identify in art that implies fieldwork (either thematic, historical or geographical), examination, collection of data, display and distribution of information. As briefly considered in Chapter 4, after the 'hybridization' of art and media in the 1960s, a whole range of crossbred practices such as art and anthropology, art and scientific research, art and urbanism; and, not least, art and journalism were brought into the public domain. It was possible, and still is, for artists to investigate new territories and bridge the realm of art with 'the real', while maintaining that certain safeness of the artistic environment. Artist Jeff Wall points out precisely this aspect of diffusion of creative practices:

> If a gallery can resemble a wellness centre, then a wellness centre may come to look like an installation piece, and even be experienced as one. Then it would not be as if anyone renounced art, but that art itself became diffuse, lost track of its own boundaries and lost interest in them. (Wall 2007: 16)

Since the 'institutionalization' of the journalistic approach (started in the 1960s and completed in the '90s), art undertook the function of counter-representation system for the political, the social, the humanitarian and the environmental. This has gained critical weight within our society. With the diffusion of committed art forms such as socially responsible street photography, political film and video and works centred on inter-subjective relations such as performance, Happenings and 'relational art' (Bourriaud 2002), the focus shifted to communication and information, leaving behind a central preoccupation with producing objects. We went from a conception of art as object and production to art as subject and context, with the artist researching, the institution producing, the viewer engaging, and all this linked within an information process that partly replaces, partly extends the media news process. Research-work outmoded the studio-work of the artist (Sheikh 2006: 193), emphasizing the production of knowledge through the investigation process rather than a production of form and a final product. Since contemporary artistic practices are rarely *not* based on research, in the following pages I propose a number of artists who do not merely use research as a working method, but turn the

Relational aesthetics is a term coined by curator and critic Nicolas Bourriaud to mark a range of artistic activities centred on situations, processes and human relations. It is an aesthetic of the encounter that somehow resembles the changing mental space opened by the internet.

information process conducted around a problem, situation, narrative into their focus. By adopting and adapting the modalities of professional journalism, these artists pay extreme attention to what surrounds their environments, and to the conditions of human existence. Their work emerged in the last decade or so, when exhibitions, forums, conferences and magazines introduced the art public to a 'journalistic turn' that expanded and preceded the idea of 'documentary turn'.

To give an idea, just between 2002 and '05 the following large-scale events brought to international attention a number of artists with an inclination towards the document, the archive, the report and the documentary style: *True Stories* (Rotterdam, 2002); *Documenta 11_Platform 5* (Kassel, 2002); the video archive *It is Hard to Touch the Real* (Munich, 2002–3; then presented in Dundee, Sheffield and Göteborg, 2004–5); *Ficciones documentales* (Barcelona, 2003); *After the News–Post-Media Documentary Practices* (Barcelona, 2003); *Fiction ou Réalité* (Fribourg, 2003); *Auf den Spuren des Realen: Kunst und Dokumentarismus* (Vienna, 2003); *Territories* (Berlin and Rotterdam, 2003); *Geography and the Politics of Mobility* (Vienna, 2003); *Home Works: A Forum on Cultural Practices I-II-III* (Beirut, 2002–5); *bb3 Berlin Biennale* (2004); *Manifesta 5* (San Sebastian, 2004); *Experiments with Truth* (Philadelphia, 2004–5); *Do you believe in Reality? Taipei Biennial* (2004); *Shrinking Cities* (Berlin and Halle, 2004); *The Need to Document* (Muttenz/Basel and Lüneburg, 2005); *Documentary Creations* (Luzern, 2005); *Reprocessing Reality* (Château de Nyon, 2005); *Concerning War* (Utrecht, 2005); *9th Istanbul Biennial* (2005); *Out of Beirut* (Modern Art Oxford, 2005); and the project series *Contemporary Arab Representations* (various locations, 2002–6). The list, far from exhaustive, demonstrates an average of eight large-scale exhibitions a year. In some cases, the political potential of the images (the content related to the real situation) stood for their poetic potential (the aesthetics). In others, the opposite was true: the political was aestheticized to make the point for this or that statement.

Artists and projects

In proposing to the reader a selection of artistic positions, I have included both tendencies outlined above: the poetic potential of politics, and the aestheticization of the political. Each of the examples adopts a different journalistic strategy, or poses different questions in relation to art and journalism. Another criterion was to give relevance to artists emerging in the 1990s or later, so like Allan Sekula, whose work from the early 1970s is a revision of social documentary photography, Sophie Calle, whose conceptual photography relies extensively on the investigative journalist's approach (Krauss 2006: 59, 2007), and many artist-activists who adopted street photography, film and video in the early days of journalistic art, are not included here. This is not an encyclopaedia of journalistic art, it is rather an attempt to cover current, distinct modes of interaction between art and journalism. The following artist's projects generate a forum where display

and dissemination of information erodes and overlaps with journalistic modes. Each example is presented via an exposé and a brief discussion of the artist's position as information producer.

Multiplicity: *Border Device(s)/The Road Map* (2003)

The installation and documentation work of the group Multiplicity advances the thesis that a growing number of borders, checkpoints, physical and psychological frontiers are the direct consequence of interconnection and movements on a global scale. *Border-Device(s)* has been presented in many venues: in Europe (for example R.O.O.M.A.D.E, Brussels; KW Kunst-Werke, Berlin; Musée d'Art Moderne de la Ville de Paris; The Talbot Rice Gallery, Edinburgh; Witte de With, Rotterdam; 50th Venice Biennial of Contemporary Art; ZKM Center for Art and Media, Karlsruhe; Konsthall Malmö; Musac Leon; HMKV Hartware Medien KunstVerein, Dortmund; Nottingham Contemporary); the Middle East (Birzeit University, West Bank; Bethlehem Peace Center; Holon Digital Arts Center, Tel Aviv); China (1st Architectural Biennial Beijing); and USA (The Fabric Workshop and Museum, Philadelphia). One specific part of this project, *The Road Map*, focused on the charged and complex territory of the West Bank in Israel/Palestine:

> It shows us an area almost completely covered with fences, fences that are falling all over each other, apparently haphazardly: war zone barriers, bypass roads that join them up, military zones for Israeli army, Palestinian villages and cities, refugee camps, areas that have no jurisdiction – a network in which infrastructures are all juxtaposed on top of each other like a giant web.
>
> Rather […] a *polyarchic* territory, impossible to reduce to two areas. (Boeri et al. 2003: 53, original italics)

To demonstrate the thesis, Multiplicity employed a quasi-scientific process: on the 13th and 14th of January, 2003, they 'measured' the density of these borders' devices, travelling on Highway 60 – from point A to point B – first with a person holding an Israeli passport, then with one holding a Palestinian passport. The travelling time in the first case was one hour; in the second case, five and a half. The reportage was then shown in art venues by means of video documentation of the two journeys, which ran for about half an hour each. There were animated scrolling texts describing the project on monitors, graphic representation of the routes, printed documentation of the journeys and the travel arrangements and exhibition catalogues. *Border Device(s)* can possibly irritate the general audience by forcing them to go through a lot of data and information, suggesting that situations in conflicts and unstable locations are never easy to decipher and therefore there is no 'fast-track journalism' here. Other questions emerge from this activity too, such as who is the audience for this type of work? And what is its purpose? Can the viewer cope with production that comprises rooms packed with diagrams, texts to be read and

hour-long video reportage to be watched, in order to obtain a full understanding of the situation?

Artist's position

Multiplicity is a group made up of visual artists, sociologists, geographers, urban planners, photographers, filmmakers, economists and architects. They organize projects worldwide through an ever-changing network recruited from the forum of intervention, into a sort of agency for territorial investigation that explores the environment of a particular location and researches the traces of new social behaviours.[1] Their use of documentary material combines the screening of moving image with archive-style arrangements, spatial displays and text-based information in an apparently scientific process of demonstration of facts. This involves: a) the formation of an always-changing team for a specific situation; b) collecting data through observation, experimentation and documentation; c) testing hypothetical research questions through findings.[2] Multiplicity do not investigate in order to propose a certain reading of things – in the sense of a possible suggestion of action – since they continuously engage in never-ending research. In fact, many of their projects' hypotheses are 'ploughed back into research and the case studies for further examination, rather than as solutions to a problem' (Boeri et al. 2003: 60). They also do not say much about the individual conflicts presented in their displays, the negotiation of these conflicts or the people affected by them. This can be a controversial point however. As a viewer, I do not know why they have chosen one particular area, conflict or phenomenon over another. Multiplicity's work is a radical, albeit obscure, way to use a journalistic approach in art. It implies an activation of the idea of the 'spect-actor', making it possible to create autonomous meanings out of the material presented, no matter what was planned by the producer in the beginning. I briefly discussed this aspect in the last chapter in relation to the writings of Derrida, Rancière and Eco, and will come back to this in the next chapter. For now, let me note that Multiplicity do not take a political stance. By presenting information in a vast, neutral and time-consuming manner, they declare things as evident, but leave the conclusions to the audience. On the one hand, their work is about rejecting the quick-point journalism typical of television news; on the other, they privilege somehow a specialized, insider audience – composed presumably of the same professionals as the authors themselves, i.e. architects, sociologists and urban planners. Viewers are capable of gathering information through the visual and written material, or by scanning the presented facts with a rapid glance, then simply moving on.

Lukas Einsele: *One Step Beyond – The Mine Revisited* (2001–2004)

One Step Beyond [OSB] is an art project that focuses on landmines, their survivors and the relationship between the two. The author searched and interviewed the survivors in four of the 82 countries still contaminated with landmines (Ogilvie 2005: n.p. [p. 185 German text]). With the help of their stories, as well as consultations with military and

minefield experts, Einsele researched mines that caused accidents and documented them in detail. The handout accompanying the exhibition at Witte de With in Rotterdam (27 January – 27 March 2005), explains:

> ONE STEP BEYOND is based on memory and stories: People injured by a mine recount the events leading up to the accident in an interview with the artist. Some make a rough sketch of the incident's location. With a field camera Einsele makes a photographic portrait of each participant, and leaves a Polaroid copy behind. Finally, in a public forum, the victims' stories, drawings and portraits are set alongside the documentation of the landmine and the photos of the area.[3]

The artist interviewed 47 survivors and took pictures of them; he also photographed the locations, activities and initiatives related to care, prevention and de-mining in Afghanistan, Angola, Bosnia and Herzegovina and Cambodia. Einsele conducted the interviews with the aid of interpreters, transcribing the accounts from the original language into German and English, and asked the survivors to draw a sketch of the location when possible. He then processed the drawing with image-recognition software. The outcome of such an investigation is an itinerant exhibition comprising texts, maps, video images, photographs, digitally processed drawings and display cases, which was accompanied by the publication of a book, an extensive website, and numerous presentations, talks, interviews and reports produced by the author and his collaborators. The results, in the words of the author, 'attempted to develop a form of representation in keeping with the medium [...] to make a phenomenon comprehensible in its entire complexity, scope, and atrocity' (Einsele 2005: 4).

Artist's position
We have encountered this work in Chapter 3, when discussing artistic context in which 'alternative' information is offered. There are considerations though. For one thing, the means of production and distribution adopted by the artist, who uses art institutions instead of magazines, television or newspapers, but without really finding innovative ways of presenting the visual material (Ricuperati 2005). The elements of research – working methodologies, documentation formats and display techniques – all relate to the sphere of journalism, and are carried out using procedures typical of television news, with its tendency to construct evidence. The visual display offers the audience a truth, constructed through eyewitness pictures of the victims and videos of rehabilitation and de-mining workers, combined with a graphic inscription that speaks illustratively for the truth on display. The technical details of the mines, the victim's account of the day of the incident and the sketch of the location supply this explanatory commentary and confirm the truth-effect of the whole installation. A second consideration is that there are no represenations of macerated body parts – the exhibition looks austere. Einsele, it

seems, has fully absorbed what Susan Sontag wrote: the pain and suffering of others is impossible to depict (Sontag 2003). He avoids the tendency to spectacularize human suffering (a trend with origins way back in Homer's *Iliad,* where accounts of Achaeans' wars remain insuperable in these terms). Catherine David, the curator who supported the production of the work while directing Witte de With, writes in the exhibition catalogue how the empty spots between one set of personal suffering and the other, the victims' photographs, create for the spectator a space of 'emancipation' (Rancière). The clinical setting of the exhibition is indeed far from newspaper or television reportage: 'Einsele neither denounces nor demonstrates; rather he insidiously disturbs the received perception of accidents and their causalities' (David 2005: n.p. [p. 52 German text]). Nevertheless, I would argue that, if not displaying suffering, OSB generates a feeling of the 'institutionalization' of the victim-saviour relationship. For instance, the dramatic black-and-white close-ups of the victims, which by intention do not represent the trauma but restore the event to history, time and space, parade a catalogue of disgrace before the viewer. The standardized proposition of facial expression of those seventeen people almost suggests that the dignity required to restore a life depends on our giving (of our time and attention, at least), and not on their taking. This would neither bear witness to the past nor restore a personal history to these individuals. Although the subjects pose consciously for the camera and are obviously aware of the image-making process, it is difficult to gauge the level of the artist's reflection on his own means of investigation. While visiting the exhibition, I could not help but wonder if OSB, in the end, capitalizes on the audience's feelings, and provides the viewers with the representative image they need as the 'dominating factor in their awareness' (Nichols 1997: 12).

Laura Horelli: *Helsinki Shipyard/Port San Juan* (2002–2003)

Helsinki Shipyard/Port San Juan comprises two video works that investigate and document the building of a cruise ship in Helsinki and the operation of a cruise ship in Puerto Rico. The two-channel video piece was originally made for a site-specific exhibition *PR'02 [En Ruta],* curated by Paula Toppila as part of the 2002 art biennial in San Juan and Bayamon, Puerto Rico. Horelli's film is based on interviews with workers – usually identified by name and job title – and inter-titles that give a broader view on the subject matter: statistics on cruise production and the cruise industry, living conditions of people working in the sector, technical details and background information. This extra information provides support for the artist's analyses of labour relations; for instance, some inter-titles explain to the viewer the conditions under which employees were allowed to speak to camera. The adopted style is that of a low-cost documentary report, with handheld camera and basic light and sound. The work's title reminds me of *Shipyard* by Paul Rotha, a 1935 'creative documentary' on the same topic, in which the director's determination to stimulate discussion on unemployment and working conditions in the British naval industry is somehow thwarted by the romanticization of the workers' skills

and the nature of the work itself. (It can be added that, unlike Horelli's work, Rotha's film was partially funded by the shipbuilders – Winston 1995: 41, Boon 2003–2008.) Reportedly, Helsinki *Shipyard/Port San Juan* provoked some surprise from the cruise employees when shown for the first time at Diner's Crew Lounge & Telephone Service, a restaurant in Old San Juan (Puerto Rico) whose customers are mainly cruise ship employees. The work was next shown in Manifesta 5 biennial in San Sebastian (2004), and Galerie im Taxipalais in Innsbruck (2005), before travelling even further.

Artist's position

Horelli's way of working is reminiscent of investigative journalism. Often stimulated by the location in which she works for an exhibition or a residency programme, she dives into local histories and narratives, assuming an observer-reporter approach, researching topics, gathering material and arranging and conducting on-site interviews. She often seeks to unravel complex relations of power pertinent to the localities. The resulting material is then associated in an intuitive, yet journalistically documented way, as summarized here:

> One thing I admire about Horelli's work is that she starts from facts, like an investigative journalist. Concerning her chosen medium, video, its use in her hands resembles an information broadcast. I like Horelli's matter-of-fact style, which trusts in the relevance of her chosen subject matter without superfluous dramatisation. (Toppila 2006: 59)

Horelli makes clear that her work is based on a subjective view, and that she is quite concerned about the practice (in journalism and art alike) of reducing some 40 hours of footage into a 30-minute video, cutting and editing snippets of information to construct a meaningful narrative (Horelli 2005: 79). Hours of questions, answers, statements and explanations had to be reduced to sound bites and become very easy to manipulate simply by taking sentences out of context or inserting in new ones. In response to this, the artist attempts to formulate a strategy of 'presence':

> I am not visible in the videos, except for during a short sequence, and my questions are only occasionally heard off-screen. In the latest works I have tried to avoid a clear self/others division by being more present in the material. I am sort of a co-participant and reveal things about myself, even if the subjects tend to reveal more about themselves. I initiate the situations and take on the main responsibility for the work, however collaborative the process. (Horelli 2005: 80)

The point is well made with regard to the artist and her 'subjects', but one problem here is what is left out of the picture, namely, the viewer's space. Indeed, in *Shipyard/Port San*

Juan one feels that despite, or perhaps due to, the journalistic attitude throughout, the message of her documentary was already decided before she started shooting. This example is symptomatic of the double edge of journalistic methodology in art: in theory, challenging the conventional one-way communication between producer and viewer (as in mass-media news) allows that space for the spectator to construct their own interpretation. In practice, the journalistic method is the least suitable of all to build such an open narrative. Different techniques can be adopted in order to achieve such a goal, and I will consider some possibilities in the following chapter of the book; for now it is suffice to say that Horelli points out one of them, namely to reveal oneself on camera. Among other methods, which I will discuss later, we might include declaring the intentions of the author (as in the next example), or adopting sub- and inter-titles that generate awareness of manipulation by the author (as in the work of Omer Fast, an artist not discussed in relation to aesthetic journalism). Once more, the bottom line here is clear: to use (or misuse) journalistic tools within the art context does not automatically make the content valuable and accessible on a different level of reading, and Horelli recognizes this limit from the off.

Renzo Martens: *Episode 1* (2001–2003)

Episode 1 is Renzo Martens' 44 minute-long pseudo-journalistic coverage of his journey to the war zone in Chechnya in 2002. The particularity of this work by the artist playing news reporter is that the camera often reverses on the author instead of focusing on the victims, soldiers and occurrences of the war, as is common practice in media journalism. The video, which can be thought of as a 'documentary performance', shows soldiers posted on the border, houses destroyed, rows of makeshift tents, UN headquarters, citizen-refugees in line to receive food – all typical images of war-torn areas. However, the role of the camera within this frame is constantly self-revealing and Martens is self-reflective. This film is about the commodification of war and the responsibilities of the viewer. The artist constantly poses the question of what his subjects think of him (what the framed thinks about the framer), reversing to some extent the relation between interviewer and subject, although this is still a construction. 'What do you think of me?' triggers harsh responses from refugees, combatants and UN-employees alike, beyond what one is supposed to say to a news camera. Turning the gaze back onto the author represents an act of performance and of provocation, which destabilizes both the subject (arguing for individuality beyond the image of 'people suffering' in the service of media representation) and the viewer (who feels shame for what the author does). According to Martens, in such situations the least important thing is to ask anguished people how they feel: what really matters is to ask ourselves, as viewers of suffering people, how we feel when we watch them (Martens 2005, 2009). *Episode 1* focuses on the fact that *we* are the visual imagery of war, which ultimately determines who has to be bombed and who has to be helped. The media coverage of the Serbian camps, for instance, eventually

determined the NATO intervention in 1995. Assuming the point of view of the television spectator, the artist confronts a reality that *is* formed by the way one watches it. Described as 'an intense, psychologically treacherous "extraordinary rendition" of shame, licence and abuse' (Andrews 2006), the film is also about the conditions of its own existence. It triggers irritation in the viewer, who feels uncomfortable at the author's performance and questions the ethical grounds for such work, in which an artist ventures into despair to untangle his own artistic and personal concerns. Furthermore, the work purposefully shows no other aspect of Chechen life than those needed to advance its theory of misery and violence and its call for humanitarian help, and in so doing endlessly reiterates media stereotypes. In both *Episode I* and *Episode III* (2008, shot in Congo), the viewer is drawn into questioning the artist for such a paternalistic and narcissistic position. Perhaps, though, this is a defence mechanism in order to avoid our answering the very questions raised: 'we are already complicit but refuse to acknowledge it, and thus project everything onto the filmmaker' (Vande Veire 2008: n.p.).

Artist's position

Martens is not interested in a specific situation (whenever or wherever it takes place) nor in the consumption of the images relating to it. What he is keen to expose is the relation of power between those who watch and those who are being watched. His oeuvre is twofold: on one hand, it makes clear that mass-media products are generally overly preoccupied with public expectations. On the other hand, the flow of information is pre-determined in terms of who sees what, when and under what circumstances: the selection of who to portray, especially when people desperately need to be seen, responds only to a 'western public that needs "sensitizing"' (Vande Veire 2008: n.p.). In short, the subjectivity of those suffering does not really matter: they depend on us watching them, and the way we see them.[4] This leads to questions about the relationship between aesthetics and politics:

> By putting the issue of his own position at the heart of the entire filmmaking process, Martens is clearly asking one of the most important philosophical questions in contemporary art, which is whether resistance and criticism are possible in the arts and whether or not there is even such a thing as engaged or committed art. (Roelandt 2008)

This critical stance is certainly not new. To make the viewer conscious of the fiction of representation was central to the theatrical work of Brecht and Weigel. And, even closer to Martens' work, in 1987 Ilan Ziv and Freke Vuijst realized a three-part television series (distributed as a documentary by Maryknoll World Video) aptly titled *Consuming Hunger*. The series wanted to demonstrate how television images of a famine of epic dimensions in Ethiopia become our consumed reality (a 'charitable opportunity' –

Winston 1995: 199), and attempted to expose media news rules and our own attitudes as viewers of people in impoverished countries. *Episode I* is perhaps more efficient in declaring the author's own position as a prerequisite for discussion of representation, as it makes it possible to trace the sources and economic impact of the representation, and to perceive what is presented as more 'objective', not through its neutrality but its transparency.

Alfredo Jaar: *The Rwanda Project* (1994–2000)

The Rwanda Project is a long-term project comprising a series of photography based installations and the book *Let There Be Light: The Rwanda Project* (Barcelona: Actar, 1998). Jaar travelled to Rwanda in August 1994, some weeks after the end of the genocide (April–July 1994) that claimed one million victims, in an attempt to compensate for the Western media's disinterest. He had followed events from the start, and travelled there to gather evidence and say more than the few lines that mainstream media had reserved for it, as well as transform conventions of 'objective' images of violence and victimization, focusing instead on the response from the viewer through survivors' tales and landscape details. Jaar initiated the series of works with *Signs of Life*, a collection of over 200 scenic and wildlife postcards of Rwanda, found during the aftermath of the genocide. As he met the survivors, he filled out each postcard with a different person's name along with the line *is alive!* and then sent to people he knew in a symbolic attempt to reverse the Tutsi death lists. Back home, Jaar felt discouraged when faced with the inadequacy of more than 3,000 images taken over a four-year period, and so developed a different strategy in subsequent installations. In one of these 'chapters', *Untitled (Newsweek),* he shows the covers of *Newsweek* and other papers in a gallery, alongside a brief chronicle of the daily events in Rwanda. The viewer learns that it took seventeen weeks (the time for the genocide to be carried out) before *Newsweek* covered the humanitarian disaster on the front page. Another installation is centred on Gutete Emerita, a woman who had witnessed the murder of her husband and sons by a death squad: photograph close-ups of her eyes are presented on light boxes in a semi-dark gallery. A text panel tells the story, which begins: 'Over a five-month period in 1994, more than one million Rwandans, mostly members of the Tutsi minority, were systematically slaughtered while the international community closed its eyes to genocide' (Jaar 1997). The same close-up is reproduced in one million two-by-two-inch slides, corresponding to the number of victims, and piled up on a light table. In another installation at the Museum of Contemporary Photography in Chicago he presented 550 prints of 60 images of different aspects of the genocide: the massacres, the refugee camps, the destruction of cities. Each photograph is sealed in a black archival box, withheld from viewers, with a text printed in white on the lid that describes the event to which the photograph inside is related. *Real Pictures* (1995) speaks of the impossibility of certain representations.

Artist's position

Jaar's work enters territories familiar to many photojournalists of recent decades, focusing on imbalances of power, both in industrialized countries and developing nations: illegal immigration between Mexico and the United States, toxic pollution in Nigeria, detention centres in Hong Kong, oil economy in Angola or the conditions of gold miners in Brazil. Jaar approaches a situation like the Rwanda genocide by trying to understand the matter as fully as possible, gathering information, talking to people, reading, researching on site; he wants to attempt an account since it is a necessary act (Agamben 2000),[5] but sometimes is caught in the same mechanism of truth-claiming that he wants to question. This is the example, in *Real Pictures*, of a sealed photograph with text:

> Nyagazambu Camp
> 48 kilometres east of Kigali, Rwanda
> Friday, August 26, 1994
>
> This photograph shows a large crowd of people waiting under a heavy sun for their names to be called by a Red Cross official. A Swiss journalist stands on his right with a microphone recording the sounds of the names being called. Engaged in an image of pathos instead of the complexity of the notion of genocide, the media has voraciously descended on the camps with cameras and microphones.

I borrow what artist and critic Joe Scanlan correctly points out in relation to this example: Jaar, in this specific case, travelled to a foreign country, took pictures of traumatized strangers and then refers to 'the media' as if he were not a part of the same system (Scanlan 1995). Like Einsele, Jaar shares with photojournalism and documentary film a space of representation, and attempts to confound expectation and subvert conventions; he tries to compensate the flaws of the media through photography, text and architecture arrangements. The aforementioned TV series *Consuming Hunger* self-consciously undertook the same effort in 1987, and asked what it takes for a historical, dramatic event to enter the circularity of prime-time news. Ziv and Vuijst did not go far in changing television's attitude towards the commodification of tragedy: 'like the commodity, famine is made and cut to measure' (Nichols 1997: 11); but what about Jaar? Scanlan maintains that, if an assumption of responsibility were to take place, it must start from Jaar himself and expand outwards, for instance by using 'we' instead of 'the media'. Only then can we ask not how should we deal with such a situation, but why we are so attracted to this kind of subject matter in the first place? However, it must be said that Jaar is aware of the limitations and contradictions implied in his work: '"The Rwanda Project" lasted six years. I ended up doing twenty-one pieces in those six years. Each one was an exercise of representation. And how can I say this? They all failed' (Jaar 2007).

Renée Green: *Partially Buried in Three Parts* (1996–1999)

This multi-layered work by Green is an archive-like installation of material involving a web of traces and memories and drawing upon several subjects: the United States and its foreign policy in the 1970s, African-American culture and Robert Smithson's artistic work. Upon entering the archive-installation, the viewer encounters Green's voice narrating her journey from New York City to Kent State University in Ohio, the site of Smithson's *Partially Buried Woodshed* of 1970. Smithson created it just before the shootings by the National Guard that killed four students during a protest against US intervention in Cambodia. Green's mother was a student at the University in 1970, and was there the day of the shootings (though apparently she remembered nothing) and childhood memories of the artist add a personal layer to the journey. In Part 1 of the project, *Partially Buried*, Green follows Smithson and investigates the idea of site and non-site and what they mean today: a reflection on 'home' and how it can be understood, if as locality or as emotional state, given the current virtual mobility engendered by technology. Part 2, *Übertragen/ Transfer*, concerns how people of German descent imagined the United States in the 1970s. Part 3 is a two-channel video projection including the video *Partially Buried Continued* and *Slides of Korea*, and is about the mingling of past and present, near and far, other and self. It includes pictures taken during the Korean War, which constitute her father's memories; others taken in Kwangju on 18 May 1980, when a student uprising ended with 288 victims; and some taken by Green herself in Kwangju and Seoul in 1997. The archive-like setting also includes the soundtracks of the two videos, which one can listen to on headphones (out of sync); photographs of the Kent State campus taken by the artist; newspaper clippings of the anti-war demonstrations at Kent State University re-photographed from James Michener's book; pictures of the town of Kent in Ohio; the University's 1970 yearbook; a box of paperbacks by Michener; LPs from the period; Crosby, Stills, Nash and Young's song about the killing of the four students (played on a tape loop) and concrete fragments of Robert Smithson's work, or the site of the work.

Artist's position

An archive might not resemble a piece of investigative journalism: it is more a depository of documents, objects, memories or even verbal narrations. How, then, can we consider Green's work as aesthetic journalism? My point is that, from where I stand (outside of the artist's personal memories and archive material), this work is a sort of do-it-yourself investigative journalism, in the sense that Green is not transforming documented facts into artworks, but confusing the perception of both. It is as if the artist is fascinated by the way in which historical and fictional documents can reveal alternative, or even contrary, versions of histories. By creating different mental spaces, she makes it difficult to separate fact from fiction, past from present, specific from general. Green questions historiography and the ordering of systems, and attempts to disentangle complex relationships between country, nationality, location, history and identity by rearranging still and moving images,

sounds and languages in new ways: 'The further the notion of home was penetrated the more it opened up and referenced other places.' (Green 2001: 131). She suggests that the past can only be partially discovered; since it is partially buried, it can be recollected through fragments, and be represented (incompletely) by means of fictions, maps and artefacts. In other words, she creates a system of references for interpreting what happens, as modern journalism does. The artist here constructs a world in order to question the way it is constructed, or a model of reality in order to ask the viewer what is being modelled. By realizing how all the hints and reminders can suddenly make sense for us, even if not strictly related to each other, and far from our daily existence, the audience becomes aware of how the 'grand narrative' (Benjamin) of the world around us is constructed in the same way. The resulting critical position questions whether systems such as journalism and art record a certain quality of the occurrences. It asks whether everything becomes dispersed in the information stream or if this quality carries weight for what is accepted or denied.

The Atlas Group/Walid Raad: *Hostage: The Bachar Tapes* (1999–2001)
In the summer of 1985 five American men were held hostage for three months in the same cell in Beirut. In their respective books on the episode, each man presents a very different account, but all describe a Lebanese man identified as Wajd Doumani, or Waijd Domani, who, for a short time, was detained with them. This is the background story for The Atlas Group/Walid Raad's *Hostage: The Bachar Tapes*. Given that Wajd Doumani, unlike his companions in detention, never wrote a book about his experience, Raad decided in 1999 to try to find him:

> After a yearlong search that took me to Lebanon, London, Boston and Damascus, and after countless discussion with former American hostages, American and Arab government officials, it became clear to me that no one knew where Wajd Doumani was and in some cases, some doubted his existence [...] Wajd Doumani no longer represented for the many individuals I interviewed a real-life individual; he had become a representative of all kinds of cultural (Arab and Western) anxieties, fears and desires about "The Western Hostage Crisis," captivity and its narratives, the Iran-Contra Affair, Islam and Muslims, Arab and Western identities. (Raad 2005: 28)

Raad then invented him as a character named Souheil Bachar, telling his story through a series of video documentations. The piece allegedly constitutes part #17 and part #31 of a series of video documents in which the protagonist, Souheil Bachar, narrates his own experience as a hostage, together with the five Americans. While each American published their experience, the Lebanese side of the story had never been told before. Raad re-writes a perception of events, opening up the possibility of reading a different history. The fact that the tapes are a production of The Atlas Group, and Bachar an actor,

reinforces the role of the journalistic and the documentary influence on the construction of what is perceived as real. Raad creates an ambiguous space of the fictional by mimicking foundational documentary structures and news archive forms, and presents such productions to reveal both the failing objectivity of history-making as well as the failing autonomy of artistic practice. Here, authenticity relies less on the content (whether the story can be true or not) than on the means of representation (the archive setting and the rough-cut, low-quality documentary video, not to mention the 'authoritative' platform in which it was presented, Documenta 11).

Artist's position

As in the work of Green, Raad constantly questions the distinctions between the artistic format as a trait of imagination and the journalistic/documentary format as that of reality (Helstrup 2003). The Atlas Group itself is an imaginary foundation that documents contemporary Lebanese history. Its activity is presented through lectures, exhibitions and an archive – a set of organized documents classified as follows: type A (produced by The Atlas Group and attributed to imaginary individuals or organizations), type FD (produced by The Atlas Group and attributed to anonymous) and type AGP (produced by and attributed to The Atlas Group). The original material is never available: only digitalized forms are presented via multimedia presentations in museum spaces and conferences. This structure gives weight to the whole project: when such documents are presented in lecture-performances and placed in contexts like Documenta 11, despite the fact that Raad introduces it as a project to collect, *produce* and archive documents, they are often mistaken for straight evidence (Wickenden 2007: 38). To assess a work like *Hostage: The Bachar Tapes*, we can refer to Jalal Toufic's interpretation.[6] This author, artist, filmmaker and long-term collaborator of Raad, does not address the question of fiction head on – i.e. by playing between what is true and what is fabricated – but rather 'reads' the actual landscape of a city, a region or a history as though it were an artwork. Both authors read the current and the factual aesthetically, escaping the division between fact and fiction; rather, they talk about this division being permanently confused, generating juxtaposition and narrative through image and text (as alternative forms of document). Ultimately, Raad's work does not document what occured, but what can be imagined, giving the opportunity to the viewer to experience what is transmitted as being as complex as the means of transmission itself (Rehm 2005).

Bruno Serralongue: *Risk Assessment Strategy* (2002)

This photographic series was generated during a class called 'Hostile Environment and First Aid', developed by the specialized company Centurion for journalists and reporters facing high-risk situations. The aim of the course is to reduce the risk for journalists sent to a war zone or an area of natural catastrophe. Serralongue shows the activity in a training camp, where journalists learn how to protect themselves from car bombs, mines, etc.

While the training anticipates future war scenarios, the photo series addresses the fabrication of future media events. In exposing the training of journalists, the author highlights the aspect of *mise en scène* in every mediatized event, and brings to the surface the power of news industry formats over the event itself (here yet to be documented). In the words of critic Carles Guerra, the artist's practice demonstrates how 'the format works like a contract that dictates beforehand what is possible and impossible to see' (Guerra 2006: 191). The images we see in photo reportage and journalism are conceived and constructed so as to confirm our expectation regarding this or that stereotype, prejudice or so-called fact, and do not really add anything to our experience of reality.[7] Images in the press or television are merely an illustration of what we have already absorbed, thanks to countless reports, real-time streaming, terror-alert breaking news and so on (Steyerl 2007). For Serralongue as for Martens, the process of journalistic news making that is coded and unable to escape its codes is at the same time a goal and a means to lay bare the problem of truth and its representation. And Serralongue turns to the roots of the process, where news is not made, but only prepared.

Artist's position
Serralongue initiated his practice in 1996, travelling to the locations of highly mediatized events: Sub-comandante Marcos at the meeting of the Esercito Zapatista of Liberacion Nacional in Chiapas (1996), the return of Hong Kong to the Chinese government (1997), the thirtieth anniversary of Che Guevara's death in Cuba (1997), the *Free Tibet* concert by the Beastie Boys in Washington DC (1998), the Expo 2000 in Hanover, the World Summit of Information Society (2003 and 2005), the World Social Forum in Mumbai (2004), and so on. Serralongue widens the discussion on the nature of truth and how it is fabricated, offering another kind of news, namely a re-appropriation of the information process through the revelation of its own making – still upheld by professions such as journalism, press agencies, broadcasting and publishing media (although now with a diminished grasp). In 1999 Serralongue was invited to choose a Brazilian institution in which to have a residency, and decided to offer his services to the newspaper *Jornal do Brasil*, joining the team of freelance photographers whose work was subjected to the daily decisions of the editor. Nine of Serralongue's pictures were published in the paper, ranging in subject from a tourist's murder to a football training session. The two series of works generated for exhibition purposes revealed the same mechanism as in *Risk Assessment Strategies*. They exposed, through elision and cropping decided by the newspaper's editor, the ambiguity of 'newsworthy' images produced for public information (Beasse 2000). Media critic and philosopher Vilém Flusser, in his book *Towards a Philosophy of Photography,* advances a concept that sounds like the theoretical backbone of such a practice: not the photographer, but the photographic 'institution' is the one producing the photograph; that is, the industry that produces the photo apparatus, and the economical-political infrastructure above that. According to Flusser

(2000), it is not the photographer's choice to determine what is photographed, but the photographic institution as such to determine the photographer, and therefore what is photographable. By revealing how an image is decided, negotiated and under what conditions it circulates even before it is created, Serralongue aims to subvert the order of image-making in photo reportage and media journalism. Jean-Max Colard writes: 'It is above all about the apprehension of time, of duration, in contrast to the instantaneity of the media event; [a sort of] antireportage' (Colard 2002: 190).

The positions described in this chapter use journalistic methods as a spine for an artistic project that involves research, making, delivering, display choices and mediation with the public. Outcomes range from attempting the objective and impartial transmission of fact to the re-adjustment of the documentary form in order to produce new models of truth via fiction and personal memories. This leads me to a further reflection: by considering the function of aesthetics not as autonomous experience but a crossing point between representation and commitment, it is possible to question the stance of the artist in relation to the matter he or she investigates. Under scrutiny, in the end, it is not the appropriateness of the journalistic content exhibited in art, but rather its methodology: the way in which artists use these forms, overturning both the traditions of journalism and art.

Notes

1. For an overview of this and other projects, including publications, and Multiplicity members' backgrounds, see www.multiplicity.it. Accessed 14 June 2009.
2. As in this passage, from: Boeri, Stefano et al. 'Border syndrome. Notes for a research program', p. 60 (see Bibliography): 'The course of the research is loosely planned in three basic phases: a series of research experiences/platform discussions (in Rotterdam, Venice, Berlin, Jerusalem) /some centralized exhibitions of the accumulated results (Berlin KW 2003, Venice Biennale 2003, Venice San Salvador 2003…).'
3. From OSB project literature, available at the time of the exhibition. See also the pamphlet *Work in Transit*, referenced p. 46 Note 2.
4. Cultural theorist Boris Buden sustains that there is no documentation evidence without immediate interpretation; it is always a sort of identification-subjectification process; that is, what the document makes of us. Lecture at BAK, basis voor actuele kunst in Utrecht, 12 November 2005, http://www.bak-utrecht.nl/videos/2005/ConcerningWar/OnDocumenting/OnDocumenting3BBuden.html. Accessed 6 February 2008.
5. Philosopher Giorgio Agamben, in relation to the witnessing of events like the Holocaust, sustains that testifying is a necessary act, but the only thing it can testify is the impossibility of testimony; yet, this has to be done.
6. For an overview of Toufic and Raad's practice, see Raad, Walid (2004), *The Truth Will Be Known When the Last Witness is Dead, Volume 1*, Köln: Verlag der Buchhandlung Walther König; and Toufic, Jalal (2003), *(Vampires) An Uneasy Essay on the Undead in Film* (2nd ed.), Sausalito, Ca: Post-Apollo. Online resources at http://www.jalaltoufic.com and http://www.theatlasgroup.org. Both accessed 17 June 2009.

7. Guerra speaks of 'extraphotographic' device (beyond representation, a pre-concept already present in our heads) to describe the process of reality-making without even approaching reality, but providing the images we expect to be reality. His argumentation draws upon the work of Vilém Flusser, quoted shortly after in the text, and Kaja Silverman.

Further Reading

Agamben, Giorgio (1998), *Homo Sacer: Sovereign Power and Bare Life* (trans. Daniel Heller-Roazen), Stanford: Stanford University Press.

Bucher, Francois (2000), 'Bruno Serralongue – A profession of the artist', in Leyton, Tanya, ed., *Vivre Sa Vie* exhibition catalogue, Glasgow: Gatico Editions, http://doc.airdeparis.com/index.php?subdir=press/SERRALONGUE%20Bruno/. Accessed 27 March 2008.

Horelli, Laura (2005b), interview with Maxine Kopsa in *IDEA arts+society*, issue 21, pp. 89–93, http://www.idea.ro/revista/edition/archive/print.php?id=581. Accessed 14 June 2009.

Jaar, Alfredo (2002), 'It is difficult', in *Documenta 11_Platform 2, Experiments with truth: transitional justice and the processes of truth and reconciliation,* pp. 289–310, Ostfildern-Ruit: Hatje Cantz Verlag.

Krauss, Rosalind (1984), 'A note on photography and the simulacral', in *October*, Vol. 31, Winter, pp. 49–68. Also published in Carol S. Squiers, ed., *The Critical Image: Essays on Contemporary Photography*, pp. 15–27. Seattle, Washington: Bay Press, 1990.

Orlow, Uriel (2006), 'Latent archives, roving lens', in Connarty, Jane; Lanyon, Josephine, eds., *Ghosting: The role of the Archive within Contemporary Artists' Film and Video*, pp. 34–47, Bristol: Picture This Moving Image.

Raad, Walid (2004), *Volume 1: The Truth Will Be Known When The Last Witness Is Dead: Documents from the Fakhouri File in The Atlas Group Archive*, Cologne: Verlag der Buchhandlung Walther König.

Raad, Walid (2005), *Volume 2: My Neck is Thinner Than a Hair*, Cologne: Verlag der Buchhandlung Walther König.

Rottner, Nadja (2002), 'Renée Green', in Documenta und Museum Fridericianum, eds., *Documenta 11_Platform 5, Exhibition Short Guide*, pp. 98–99, Ostfildern-Ruit: Hatje Cantz Verlag.

Serralongue, Bruno (2004), Interview with Astrid Wege in *Multiple Exposure*, exhibition catalogue, Innsbruck: Galerie am Taxispalais and Frankfurt a/M: Revolver.

Sekula, Allan (1986), 'The body and the archive', in *October*, Vol. 39, Winter, pp. 3–64.

Silverman, Kaja (1983), *The Subject of Semiotics*, Oxford and New York: Oxford University Press.

Wallis, Brian (1997), 'Excavating the 1970s – installation art, Renee Green, travelling exhibition', in *Art in America*, September, http://findarticles.com/p/articles/mi_m1248/is_n9_v85/ai_19785379. Accessed 30 January 2008.

Chapter 7

WHY is Aesthetic Journalism Relevant, Now and in Perspective?

By this time, we know that the interaction of aesthetics and information is the foundation upon which we construct our thoughts and opinions, and shape our idea of society. The more we develop our being, the more important is the exchange of information, and the impulse to expand knowledge. Humankind is set apart from other species (and from machines) by this all-encompassing aesthetic approach, which can be roughly sketched as a two-stage process. First, we consider all the signs we receive from the environment, and not just the few related to basic needs, like food or shelter (Montani 2007: 40); secondly, we translate the manifestation of things into information through interpretation (Weizenbaum 1976). For this act of interpretation, the key element is the acquisition of the skill to formulate the right question about those signs (if unconscious) or signals (if deliberate) and transform them into information. Press and broadcast news are realms in which our concept of truth takes form. Visual art, on the other hand, is increasingly present in the communication of urgencies; hence, the hypotheses I have advanced (Chapter 5) about the idea of truth shifting from the sphere of news media to the territory of art, moving out from the private realm (of the object, the person who produces or consumes it, the meaning carried through the object) to enter the public sphere (the issue at stake, the process undertaken, the distribution of knowledge). This attitude sets a new 'horizon' of sense, bringing the matter outside the established traditions of formalism (for art) and reporting (for journalism). Albert Einstein reportedly stated that we cannot solve our problems at the same level of thinking that has generated them. With art and journalism, if we open up and re-think our conception of traditional information formats, allowing imagination and open-endedness, we might perceive things in ways we remain unaware of. In this sense, while journalism reports, and fiction reveals, aesthetic journalism does both.

Different strategies

The combination of professional capacities of journalists and artists may generate interesting possibilities: it is a matter of diversifying what is now uniform. In aesthetically approaching events in contemporary life, what appears to be real, true or verifiable cannot be detached from the system of representation adopted. The difference between representation as such (considered artistic) and commitment (considered political or socially relevant) is somehow levelled out. Are we now misunderstanding non-fiction as information? What can we initiate with elements of reality brought into art? Is a witness account – which involves time and participation – a viable substitute for a reporting

position? I would like to propose a number of strategies for this interaction, if journalism were approached as an art form or, conversely, if art were considered a journalistic method. What changes would we encounter? Can the coded practice of journalism shift its supposed objectivity to a transparent subjectivity by means of the artistic 'experience'? Can artists embark on the same process, transforming their practice into something close to a public service, with a declared agenda? Let me outline a few approaches worth considering at present and in the future.

Witnessing: making time

A witnessing experience is centred on the issue of time. Art is one of the few realms in which time is still a negotiable term. As documentary filmmaker Sanjay Kak proposed in an article, art producers could think of adopting the 'witness-of-events' approach as an alternative to the typical report of the news producer (Kak 2004: 325). He argues that it is crucial, in a work of representation, to go beyond the simultaneity, which remains the primary task of current television and printed press journalism. The fundamental difference between a journalistic work that 'reports' and one that 'witnesses', is in the approach of the producer to a mode of revelation that exposes and represents facts without anesthetizing them. This line of thought makes evident the paradox of mainstream journalism covering complex issues with twenty-second soundbites, in order to make them digestible for an audience. In an ideal system of representation, the spectator adds subjective meaning to the images and sounds proposed, and in this way overcomes the immediacy of the report (the bodily impression created by the senses). The work of Renzo Martens considered in the last chapter may provoke, in positive as well as negative terms, such a reaction. The viewer grasps a fragment of things and from there builds upon this, engaging their own perception, producing little actions, being aware of the impulses that provoke them; not imposed from the outside, but generated from within. In our daily digest of representations via TV and newspapers, however, this does not happen: the current trend of event reporting is problematic because it renders no space for critical distance. This concern is no new thing in media critique, yet is vaguely perceived when it comes to journalistic art. More than ever, we need a witness attitude in art, for it might inspire a witness attitude in journalism: a kind of knowledge looking beyond what is immediately visible, a latency, so to speak, an imaginative reading of what is not directly accessible to the senses. Witnessing is not reporting: it implies a plurality of points of view, and the passage of time, which is not permissible in the current media news environment. Artists and art institutions, instead, can produce works over a span of months rather than minutes, and can adapt their agenda (because they have time) to the witness approach. This way, it creates the time to add idea upon idea, returning in several steps to the same subject, and allowing the space to think, digest and re-work what has been the object of the investigation. The main argument opposing this approach is that the economic impact of witnessing is problematic for media news production:

producers are unable to spend months of work on a single issue. Nonetheless, I would suggest that a longer and 'in depth' investigation (from theme to theme) allows connections with many other related issues, and provides the chance to make more works, distribute them and possibly generate economic return from different commissioners. Importantly, this form of production of information is an option in both documenting and fabricating fiction, since it depends not on the author or the subject, but on the receiver. This line of reasoning actually mirrors the present criticism of our digital age:

> What is necessary is a reappropriation of time. At the moment there is simply not enough of it to stroll around like a flaneur. All information, any object or experience has to be instantaneously at hand. Our techno-cultural default is one of temporal intolerance […] Usability experts measure the fractions of a second in which we decide whether the information on the screen is what we are looking for. If we're dissatisfied, we click further. Serendipity requires a lot of time […] With Lev Manovich and other colleagues I argue that we need to invent new ways to interact with information, new ways to represent it, and new ways to make sense of it. How are artists, designers, and architects responding to these challenges? Stop searching. Start questioning. (Lovink 2008)

Cultural producers could 'use' the passage of time by applying an attentive eye to current and manifest aspects of the matter analysed, but also to the historical background that produced it, to what is concealed to the eye and to its possible or imaginary development. To pursue an aesthetic approach in a journalistic representation can reveal aspects of reality otherwise buried beneath real-time coverage of occurrences. A carefully crafted image or act, for instance, with an elaborated mode of production, can propose 'a deeper kind of reflection on important subjects too often lost in the media's glare' (James 2008: 13). It is also important to have the possibility of repeated viewings, since reality is not a language in itself but the condition for a language (Bruno 2006: 112, quoting the philosopher Emilio Garroni). It takes time to decide how to (and if to) relate to all aspects of a situation and the people and stories told in the work. It takes also time to assess what could be true or false, right or wrong, and ultimately to decide where one – as a viewer – stands in relation to ethical and aesthetic issues. If we, as a public, accept the opportunity to 'develop' in time this or that topic, as part of our own story, we activate a witness process (Enwezor 2003a, 2004). It is a matter of adding knowledge, linking what we already know with what we do not know and putting the new in sequence with other knowledge. Two aspects are equally important: for the author not to be forced to adapt to the speed of the news industry, and for the spectator not to be required to accept or refuse it on the spot. Come and go in front of a representation at one's leisure, be irreverent to the format of the reproduction of things, take time to make sense of what is presented – all these opportunities must be kept alive in artistic practice, to eventually

expand back into traditional journalism and other news formats. The previously mentioned *Phenomenology of Journalism* exposed clearly, a few decades ago, the issue of time in art and journalism:

> The journalistic attitude is related to the reporting of events in this world by media which have, as one of their central characteristics, periodicity in publication, whether it be a daily newspaper, a weekly or bimonthly journal or a radio or television program. The act of reportage is limited, not only in the sense that it conveys an image of the world defined within the framework of the reported event, but also by the periodicity of publication [...] Thus, regardless of the state of completeness of his research and knowledge, [the journalist] must present a story which appears to be a complete entity by the time of his deadline. The element of completeness in the story, the who, when, where, and how, of journalism, resembles the images of a total world as presented in a work of art, so that in this respect the journalist is an artist, who, however, works in terms of time demands which are generally not characteristic of the artist. The requirement, however, that the story appear to be complete in and of itself forces the journalist to work for a closure which is not the closure that might have occurred had he not been subject to the time requirements. (Bensman and Lilienfeld 1969: 99–100)

Unlike the work of the artist, who focuses on representation but is relatively freed from time-bound issues, the journalist's is a work of estimation, an act of creation with an eye on the consumer and another on the deadline. I would agree with the authors above that, *de facto*, the journalist *is* an artist, despite the completely different timeframe in which they work. In these terms, aesthetic journalism is a given fact, not a supposition. It only needs to be 'timed'.

Interactivity: removing the visible, adding the meaningful

An exchange of points of view is what Cubism and earlier Soviet cinematography (Shub, Vertov, Eisenstein, et al.) proposed in their experiments at the dawn of the twentieth century. The representation of objects and situations from many angles, on the same canvas or in a film scene, introduced the elements of time passing, which became a fundamental element of our age: the (often controversial) principle of simultaneity, which goes beyond its time-element. The World Wide Web and real-time transmission depend on this principle of organization, in which it is not the similarity with the real that is important, nor its speed rate, but the development of an 'essence' of reality that works at the level of imagination. This idea of simultaneity, and of the participation of the final user in the production of meaning, was further theorized at the beginning of the 1960s. *The Poetics of the Open Work* by Eco provides not only the general idea of 'performativity' by the viewer, which results in the completion of the work by the gaze

of the spectator (as seen in Chapter 5); it gives also the theoretical framework for the use of documentary, interview, reportage and lecture in artistic practice. In a passage of the essay, Eco gives the example of the dictionary:

> Now, a dictionary clearly presents us with thousands upon thousands of words which we could freely use to compose poetry, essays on physics, anonymous letters, or grocery lists. In this sense the dictionary is clearly open to the reconstitution of its raw material in any way that the manipulator wishes. But this does not make it a 'work'. The 'openness' and dynamism of an artistic work consists in factors which make it susceptible to a whole range of integrations. (Eco 1979: 62–63)

For Eco, these factors are the mechanisms of interaction set by artists during the creation process, and by the audience during the reception process, in a mutual exchange that gives meaning to the work. The interpretation is to be understood as a productive process: reading a text, or watching a video, means essentially to produce another text or video. This combination of point of view is what we can call interactivity, to which other theorists paid attention: Pietro Montani attempts to give a schema of interactivity through five levels of 'difficulty' (Montani 2007: 113–116), starting at level one with the use of technical instruction manuals. It proceeds then with the production of some 'original' outcomes through play (videogames, uploading material on YouTube, hacking computers), the employment of multimedia tools for research (CD-Rom encyclopaedias), the art installation to be 'used' by the audience (which nevertheless interact within the provided framework) and, finally, at the highest level, the inclusion in the work of the *fuori-campo* (outside the frame) image. This last level indicates the possibility to go beyond what the artist or author has set for their viewer. Montani provides two examples of this sort of artistic interaction, both taken from cinema. One is *Historie(s) du Cinéma* by Jean-Luc Godard (1998), a series of video essays on the history of film in the twentieth century, a body of work originally conceived as a series of talks in Montreal in the 1970s. In one part of the work, the director constructs a narrative account of the Holocaust through the relation and conflict between images; namely, an image of Holocaust footage dissolving into an image of Elizabeth Taylor in *A Place in the Sun* (1951) – a juxtaposition that theorist Libby Saxton addressed as obscene yet 'fertile' (Saxton 2003). The other example (Montani 2007: 118–120) is *ABC Africa* by Abbas Kiarostami (2001), a film where the viewer sees the director in the act of filming the subject of the film. The director conceals the images of his own camera, but makes accessible to the viewer his own image while shooting, as in Brechtian 'estrangement'. I would also like to reconnect here with the idea of the withdrawal, which we encountered in the work of Jalal Toufic and The Atlas Group/Walid Raad. Withdrawal is an act calculated to defy the efficiency of the cultural screen (Chapter 5), by telling a story that is different each time and being aware of our constant fallibility. In the words of Toufic:

One of the main troubles with the world is that, unlike art and literature, it allows only for the gross alternative: understanding/incomprehension. Contrariwise, art and literature do not provide us with the illusion of comprehending, of grasping, but allow us to keenly not understand, intimating to us that the alternative is not between comprehension and incomprehension, but between incomprehension in a gross manner and while expecting comprehension; and incomprehension in an intelligent and subtle manner. (Wilson-Goldie 2005: 92; Raad 2006: 243)

We know that any claim of truthful perspective cannot exist; it can only be presented as such, since a representation (whether journalistic or artistic) is always developed and sustained within a prevailing cultural system. The withdrawal concept is a measure to counter this claim, based on two approaches: a) showing an image that reveals not its content, but refers to something else, outside the picture; b) not showing an image at all. In short, it means to keep the representation of facts, and therefore history, in 'suspension' (Clifford 1988).[1] Withholding visual evidence, or information in general, it is seen as a lack of professionalism in journalistic criteria; however, what is deficiency in one field, can be wealth in another. What is important is not a detailed account of facts, but how these are portrayed and why some others are omitted. It is always relevant to open up the possibility of seeing something different in what is told; not claiming to tell 'what it is all about', but rather proposing a selection of possibilities of reading.

Further examples exist in this sense. One is the 2003 video *Schwarz auf Weiss. Die Rückseite der Bilder* by the art collective Klub Zwei (Simone Bader and Jo Schmeiser),[2] in which a succession of images of the Shoah is withdrawn and substituted by a text referring to those images and a voiceover. What the viewer sees are white words on a black background, and it is this powerful removal of the pictures that are spoken of, which instigates in the spectator's mind a reflection on reality, that distinguishes an image as a historical document (Gludovatz 2003). Klub Zwei maintain that what creates this distinction is not the content itself, but rather the circumstances in which the content is presented, and those in which it was produced. In the case of the Shoah, this is traceable on the backs of the pictures, with their notes and stamps. The evidenting side serves, most of the time, as an illustration of authenticity, as a symbol, but is not there, where one finds relevance. In *Forthcoming* (2000), Toufic cites the possibly fictional photographer who was sent to Bosnia to document the destruction of the war, and returned 'with thousands of largely blurred and haphazardly framed photographs of intact buildings with no shrapnel, with not even broken glass' (Toufic 2000: 71). In seeing those pictures, one could perceive the war in Bosnia all the same, precisely through the intactness of the cityscapes portrayed in the images. Another example of withdrawal occured during a seminar held in Berlin at the beginning of 2007, where Walid Raad, in presenting and developing his lecture *as* work (and not *about* his work), commented: 'I can't remember why we did this, but let's read it back and explore it' (Raad and Toufic

2007). Now, regardless of the truthfulness of his forgetting, what counts is the position of perennial re-work, research and reading of things, avoiding what we could call 'the statement of reality'; it requires us to suspend our notion of the 'experienced' as something fixed and immutable. This attitude does not create fiction, but changes the mode of reading a work: first exposing some fabrication, and then withdrawing it immediately. This goes hand in hand with the disappearance of art as a distinct autonomous and coded (with specific media and tools) practice, and with the idea of interactivity explored above. The facts themselves are artworks, precisely because they are processes. The idea of representation of the others, and of the self, is not immutable, but constantly in a state of becoming (Wood and Zurcher 1988). What we are is attributed by others; what we see, by ourselves. That is also why I call this new mode of journalism 'aesthetic': it happens when we take facts as artworks and artworks as aesthetic facts. As mentioned earlier, it questions, and levels out, our idea of representation as an artistic effort, and of engagement as a political one.

Hijacking: on art and journalism
As challenging as it sounds, this is an open invitation to produce investigative works not exclusively for the artistic scene, but also suitable for different communication formats: a partial seize of the broadcasting and publishing space by the artist. The artist-as-journalist is able to research opportunity in many fields and circumstances; resourcefulness is one of the skills of art people. I think of an expansion of the range of opportunities beyond galleries, museums, biennials, fairs and residency programmes to initiate a relationship with magazines, television stations (from the local TV network to satellite broadcasters) and radio channels, which often are in search of a 'fresh eye'. There are past examples of artists working with mass media in one way or another. In the 1960s and '70s a generation of programme-makers and artists worked together to explore (and indeed, expand) the potential of television to 'project' ideas, and educate without patronizing (Smith 2009: 140). If, before that time, arts television was a matter of reducing art to a series of 'great men', and from the 1980s onwards is able only to celebrate either celebrity status or economic aspects of the art world, in-between these two decades a number of things happened in the relationship between art, TV, radio and magazines. Artists attempted to 'insert' themselves into these communication channels, subverting or desecrating the authority of broadcast and press media. Some turned television, cinema and publishing into a game of celebrity and death, *in primis* Andy Warhol. He understood well ahead of anyone else the potential of the medium of television (and its Technicolor) in order to reach a far greater audience than any other arts medium, beginning with his 1964 rather bizarre BBC interview session with Susan Sontag, and continuing with *Andy Warhol's TV* for cable and *Andy Warhol's Fifteen Minutes* on MTV. Artists and programmers also used television to 'try things out', as in the filmic experiments by Alasdair Gray on BBC (a hoax film about his own death, 1965) and BS

Johnson's *Fat Man on a Beach* on HTV Wales (an hour's worth of various distractions from the fact that the viewer is watching what is described in the title, 1973). Writer and critic John Berger's *Ways of Seeing* (also broadcast by the BBC, and in print version, 1972) was a programme that de-constructed our understanding and taste in relation to art, using music and pan-technique when describing the artwork, and pointing to the 'false religiosity' surrounding art. Gerry Schum with his *Fernsehgalerie* (Television Gallery) arranged exhibitions to be transmitted by the public broadcasting service of West Germany. With a strong approach summarized as 'communication rather than possession of art', Schum produced two tele-exhibitions. The first, *Land Art*, a 37-minute transmission about the work of eight international artists (Marinus Boezem, Walter de Maria, Jan Dibbets, Barry Flanagan, Michael Heizer, Richard Long, Dennis Oppenheim and Robert Smithson), was on air on SFB in Cologne on 15 April 1969. The second, *Identifications* (twenty artists invited to react to the medium of television), went on air on Südwestfunk in Baden-Baden on 30 November 1970. The state television WDR also broadcast artist's interventions by Keith Arnatt (*TV Project Self-Burial*, broadcasting his photograph for two seconds prior to or during prime-time viewing, 11–18 October 1969) and Jan Dibbets (with Schum: *TV as a Fire Place*, 24 minutes in which he ironically addresses TV as the modern heart of the house, Christmas week 1969).[3]

Another approach artists employed was to place themselves into original broadcasts, and use it as a platform for disclosing language policy. A few examples are the TVTV (Top Value TeleVision) transmission *Four More Years*, an irreverent cover of 1972 Nixon's campaign and the Republican Convention; Chris Burden's piece in which he took a television hostess hostage during a live programme (*TV-Hijack*, 1972); or his buying up of TV advertising time as an artwork (1976) with the aim of illustrating to the viewer the control television has on their life; the 1980 series *Amarillo News Tape*, which managed to be simultaneously objective documentary, subjective socio-political reading and a blank space for interpretation. More recently, artists, filmmakers and authors turned (again) to mass media as a channel to extend the reach of their public. In Germany, Alexander Kluge made experimental programmes on RTL and Sat 1 from 1988 onwards; in the UK, the advent of Channel 4 provided the chance for producers to propose (and have accepted) artist's programmes under these terms:

Amarillo News Tape was a TV programme by artists Doug Hall, Chip Lord and Jody Procter. They used the facilities of the television station Pro News Team in Amarillo, Texas. Their purpose was less to parody the news itself than to reflect on its style and ritualism.

(i) choose to produce a one-off or a series. These would not have to conform to a particular duration or C.4 slot; (ii) that the work should appear in its own right & not to be contained within another programme or be compiled together; (iii) have access to production techniques and equipment necessary to produce the idea […] be granted

a budget appropriate to their requirements and be paid for their work on the same basis as other TV production personnel; (iv) choose the time of transmission and frequency (in the case of a series) as far as possible. (Ridley, 2008: n.p.)

Within this framework, from 1984 onwards artists like John Latham, Ian Breakwell, David Cunningham, Stephen Partridge, Rose Garrard, Rosemary Butcher and Michael Nyman (in collaboration with Paul Richards) all realized TV formats. Breakwell in particular explored the opportunity, with two TV series on Channel 4 (1984 and 1988), and a series of programmes on BBC radio (Lewison, Ridley, Hammond and Lubbock 2007). Isaac Julien made a television version of the mentioned art-drama-documentary film *Frantz Fanon: Black Skin, White Mask,* which was broadcast in December 1995 by BBC (UK) and was seen by an audience of approx 900,000 viewers (Julien and Nash 2000). Changing medium, throughout the 1990s artists such as Cornelia Parker, Jenny Holzer and Christian Boltansky published artists' interventions in widely distributed magazines such as the science community's leading magazine or the supplement of a daily newspaper. This has proved to be highly successful for both parties involved, and quite an extraordinary experience for the reader.[4] On another level, the project *Guerrilla News Network* is an example of hijacking media, whose aim is to make programmes about socio-political topics (war on terror, environment, intelligence and so on) driven by a musical narrative. In an interview to GNN's co-founder Stephen Marshall, theorist Geert Lovink introduced this initiative as follows:

> On GNN, it is trance meets Chomsky. Without leaving behind the tradition of political documentary video and investigative journalism, GNN uniquely frames classic footage in an innovative television format. Edited as high pulse video clips, the works are designed as interactive art works and distributed simultaneously on VHS, DVD, as television signal and, last but not least, as streaming video content on the web. (Lovink 2004: 294)

Behind this idea is the belief that the public does not respond to academic or verbose language. Marshall put it very simply: producers can either snub the populist approach to information, and give way to manipulation of facts and representations; or embrace the realm of advertising, music videos and similar pop formats in trying to build a meaningful commentary. In Lovink's words: 'Weaponize the media. And this is what we are trying to do with GNN'[5] (Lovink 2004: 299).

There is no doubt that an artist – whether a DJ or a painter – strives to create works that become 'subliminally subversive': instinctively pleasurable and critical at the same time. I believe an artist may better pursue a collaboration with other media such as journalism, rather than expecting this or that media opportunity; providing expertise, time and attention, and demanding a funding and distributing structure in exchange.

This has been a reality in the past (as in Channel 4 productions of the 1980s), and can be re-negotiable now and in the future. It is possible to extend and multiply the artist's work in many different arrangements. While I am aware that the 'intrusion' of art in the sphere of media journalism requires subjugation to its rules it is nevertheless worth the attempt, since reciprocal influences between viewers, media and producers are not entirely foreseeable, as Rancière, Derrida, Eco and others pointed out. In fact, to ground the idea of 'reality' in its reception rather than its representation is one way to retain the ability to build our own 'truth claim' for what is represented, instead of the material making such claims for itself.

Disclosing: playing with mechanisms

News making is a complex interaction, as the public is exposed to the journalist's influence, but at the same time 'suggests' what is worth taking on. In fact the journalist is expected to anticipate their spectatorship's response; that is, the excitement and stimulation that will possibly titillate the public (Simmel 1964). In exposing the possible strategies for a new journalism, Elfriede Fürsich recommends that, since not all the sides of a representation can be known, information providers have to invent systems to reveal the conditions of production of that information (Fürsich 2002: 72). Journalism has to allow a range of reading of what it produces, re-channelling the constant shift of attention to focus more 'vertically'. A couple of stratagems could be employed to achieve this, in particular:

1. Alienation. This is inspired by the work of Brecht and Weigel. As seen in Chapter 4, their *Verfremdungseffekt* (alienation effect) as theoretical and practical method for their theatre in the 1920s devised techniques such as non-emotional acting and out-of-context dialogue or costumes. In essence, they disturbed the audience's connection to the play. In some circumstances, the technique of *Verfremdung* has been used in television by displaying production methods and so breaking with viewers' expectations (for instance, by developing entertainment formats such as reality TV and behind-the-scenes). However, this has not really or satisfactorily been attempted in the production of information. Fürsich reports a few examples of alienation occurring in the representation of the other, when '"locals" "did not play along"' (Fürsich 2002: 74). In one instance, in a programme by Lonely Planet Television, a tribe chief in Namibia replied to host Andrew Datta: 'You are coming from very far for making a lot of money with this film.' Apparently caught off-guard, the host could only remark, indicating the camera, that it was not him, but 'them' who were making the money. Moments of alienation like this, if shown, would allow the subject of the investigation to be framed other than as a picturesque image.
2. Play with representations. This implies including the production crew in the scene, that is, within the frame of the visible, to make it transparent: 'By showing the camera

and the production staff, and through specific editing techniques, the constructedness of the shows and its representations could become more visible' (Fürsich 2002: 76). These techniques are normally avoided in media journalism, where crew and set-ups remain hidden, except when this facet is used to provide that feeling of being 'here and now', which is supposed to help the appreciation of truth (i.e. the set-up of the news studio as a real pressroom; or the 'making of' trailer of TV programmes). For most of the other cases, the element of transparency is played out through experimental or authorial cinematography. The previously mentioned film *ABC Africa* by Abbas Kiarostami is a case in point, since we see the images of the location and the director's work as he is filming, but we do not see the images that his camera is shooting – an attitude close to *cinema-vérité* and in particular the work of Jean Rouch. In his *Chronique d'un été*, a film realized with sociologist Edgar Morin in 1961, the issue of objectivity was taken on board and 'solved' by placing themselves in the film (as other artists and filmmakers such as Chris Marker and Jean-Luc Godard did later). It has to be said that *cinema-vérité*, in turn, owes much of its theoretical perspective to the work of Dziga Vertov: *The Man with a Movie Camera* (1929) is a film in which his own camera tracks a cinematographer through the city as he in turn shoots urban scenes. In any case, even artistic or journalistic works that play with the 'self-reflexive' strategy rarely escape pitfalls of some form. I cannot recall many productions addressing the reason a team, reporter or artist has chosen that location and that particular subject. Even more rarely it happens that producers make the viewer aware of the implications (economic or otherwise) behind those choices.

Horizon(ing)

Could aesthetic journalism be the next 'horizon' of meaning, as proposed in the beginning of this chapter? I do not know, and cannot claim such a thing. What I have done, rather, is to sketch an articulation of the relationship between artistic and information activities; not to construct a theory, but to instigate responses; not to freeze art into concepts, but to find possible ways of working. As mentioned in several points throughout the book, there is an inevitable division between the individual experience of something and its representation. Our personal occurrences cannot be true for someone else; its 'knowledgeable' representation, on the other hand, completely escapes individual experience (Jameson 1991).[6] The gap between the actual incident and its model is also the place of difference between the artistic and the journalistic form of representation. Hence, in my view, the necessity to expand access to aesthetic journalism by acting upon both art and journalism, broadening their respective practice to the point of including other formats as agents of change. Potentially, the term 'media worker' could be used not only for journalists, TV or internet producers (the so-called content providers) but also for artists, performers, musicians, storytellers and poets. Producers

who include in their work possibilities such as the use of imagination, open-ended meaning and the individual interpretation of documents can expand fruitfully the journalistic attitude. Aesthetic journalism works by combining documents and imagination: the necessity of the former and the desire of the latter, since desirability is almost an antidote to the often senseless accumulation of information. This would counter the attempt to be objective at all costs, and would not discard creativity in favour of neutrality. It is useful to remember that creating fiction does not mean telling fancy stories; it means undoing the connections between things, signs and images which constitute what we intend as reality (Rancière 2006a).

To comprehend further this proposition in the context of this book, we could look at something outside art or media and apply to aesthetic journalism the argument of 'exaptation', as opposed to 'ad-aptation'. Studying the biological design of the living species, scientists Elizabeth Vrba and Stephen J Gould coined the term *exaptation* to indicate those characters that appeared for a specific reason in the evolutionary process, but developed further to become a broad and universalized element of survival (Vrba and Gould 1982, Gould 1991). In parallel, the journalistic trait of art first developed to expand its grasp on life, since the tools at its disposal were no longer enough; that trait could now ex-apt and shape the subsequent view of the world by returning full circle to journalism and the media news industry. Whether or not this aesthetic approach will be *the* essential feature of our understanding of the world, only time will tell. In any case, it could provoke a state, or perhaps more a process, of 'sustained curiosity', and in turn change me, as user of information, through an attempt to comprehend what I am curious about and therefore unaware of

An exaptation is a character evolved for a purpose other than that for which it is currently used. A trait, evolved to serve one particular function, ultimately serves another one. Bird feathers are a common example: initially evolved for temperature regulation, they were later adapted for flight, which became the main feature of birds.

(Huberman 2007). More than a phenomenon of compensation, I see aesthetic journalism as an instrument with which to render sharper and more persistent my curiosity, and make more visible the contours of reality (Jameson 2005). In fact, to think about something in a 'secure' way by means of structured information, as in traditional journalism, is to reduce the unknown to the expected, and therefore take away the possibility of learning.

Notes

1. The 'suspension' advanced by Clifford implies that cultures are to be considered not as 'organically unified or traditionally continuous but rather as negotiated, present processes'. See text in Bibliography, p. 273.

2. For more info on Klub Zwei, see http://www.klubzwei.at. Accessed 18 June 2008.
3. Other early interactions between art and the medium of television took place in the United States, for instance the 'videoviews' series, videotaped dialogues with artists by Willoughby Sharp broadcast by the San Jose State TV studios in 1970; and the artist-in-residence work of Nam June Paik at Boston's Public Broadcasting Laboratory in the early 1970s. Back in Europe, Peter Weibel produced his television action *tv und vt works*, broadcast by Austrian Television (ORF) in 1972.
4. See in particular the 'Avoided object' contribution by Cornelia Parker in *Nature* magazine, 20 October 1997; and the 'Da wo Frauden sterben bin ich hellwach' 30-pages contribution by Jenny Holzer in the *Süddeutsche Zeitung Magazine*, 19 November 1993.
5. For more info about Guerrilla News Networks: http://www.gnn.tv. Accessed 14 June 2008.
6. Critic Fredric Jameson examines the dichotomy between individual experience and its scientific model, which, by extension, implies the difference between an artistic attempt versus a journalistic attempt to express the authenticity of political events.

Further Reading

Baricco, Alessandro (2006), *I Barbari. Saggio sulla Mutazione,* Roma: Fandango, http://www.repubblica.it/rubriche/i-barbari/index.html. Accessed 15 December 2007.

Bourriaud, Nicolas (2002), *Relational Aesthetics* (trans. S. Pleasance and F. Woods), Dijon: Les presses du réel. First published in French, 1998.

Buden, Boris (2005), lecture at BAK, basis voor actuele kunst in Utrecht, 12 November 2005, http://www.bak-utrecht.nl/videos/2005/ConcerningWar/OnDocumenting/OnDocumenting 3BBuden.html. Accessed 06 February 2008.

Capucci, Pier Luigi (2005), *Art, Multiplicity and Awareness*, http://www.noemalab.org/sections/ideas/ideas_articles/capucci_art_multiplicity/capucci_art_multiplicity.html. Accessed 20 October 2008. Text of lecture given at ARCO 2005 International Forum: Art and Technologies II, in the panel 'Art in the Garden of Diverging Paths', Madrid 12 February 2005.

Godard, Jean-Luc (1998), *Jean-Luc par Jean-Luc Godard I and II (1950–1998),* Bergala, Alain (ed.), Paris: Cahiers du Cinéma.

Gludovatz, Karin (2003), 'Dokumentarische strategien in der kunst', handout for the lecture series *Dokumentarische Strategien in der Kunst*, Vienna: Museum Moderner Kunst.

Kant, Immanuel (1999), *Critica della facoltà di giudizio*, E. Garroni and H. Hoenegger, eds., Torino: Einaudi; English version Paul Guyer, ed. (2000), *Critique of the Power of Judgment* (trans. Paul Guyer and Eric Matthews), Cambridge: Cambridge University Press.

Margalit, Avishai (2002), 'Is truth the road to reconciliation?', in Ghez, Susanne; Enwezor, Okwui; Meta Bauer, Ute; Basualdo, Carlos; Maharaj, Sarat; Nash, Mark; Zaya, Octavio, eds., *Documenta11_Platform2: Experiments with Truth. Transitional Justice and the Processes of Truth and Reconciliation*, pp. 61–64, Ostfildern-Ruit: Hatje Cantz Verlag.

Morel, Genevieve (2002), 'The "melancholization of the witness": The impotence of words, the power of images', in Ghez, Susanne; Enwezor, Okwui; Meta Bauer, Ute; Basualdo, Carlos; Maharaj, Sarat; Nash, Mark; Zaya, Octavio, eds., *Documenta11_Platform2: Experiments with Truth. Transitional Justice and the Processes of Truth and Reconciliation*, pp. 79–96, Ostfildern-Ruit: Hatje Cantz Verlag.

Nagel, Thomas (1986), *The View From Nowhere*, New York: OUP.

Norris, Christopher (1990), *What's Wrong With Postmodernism: Critical Theory and the End of Philosophy*, Baltimore, MD: Johns Hopkins University Press.

Rosler, Martha and Chan, Paul (2006), *Between Artists*, New York: A.R.T. Press.

Rouch, Jean (1985), 'The cinema of the future?', in *Studies in Visual Communications*, 11 (1), Winter, pp. 31–35.

Sachs, Albie (2002), 'Different kinds of truth : The South African Truth and Reconciliation Commission', in Ghez, Susanne; Enwezor, Okwui; Meta Bauer, Ute; Basualdo, Carlos; Maharaj, Sarat; Nash, Mark; Zaya, Octavio, eds., *Documenta11_Platform2: Experiments with Truth. Transitional Justice and the Processes of Truth and Reconciliation*, pp. 43–60, Ostfildern-Ruit: Hatje Cantz Verlag.

Žižek, Slavoj (2002), 'More real than reality', in Lammer, Christina, ed., *DoKu: Kunst und Wirklichkeit inszenieren im Dokumentarfilm*, pp. 75–79, Vienna: Turia und Kant.

Chapter 8

REFERENCES and Niceties

The most valuable reference I will make is to the people I have shared this effort with. Hence, the reference list is, first, a thank-you list.

Acknowledgements

I am in debt to many. For inspiring: Anke Bangma, Katharina Jedermann, DFW, Simon Sheikh. For revisions, suggestions and comments: Lorenzo Biagini, Joanna Callaghan, Francesca Colussi, Geoffrey Garrison, Nanna Guldhammer Wraae, John Hopkins, Jane Jin Kaisen, Fay Nicolson, Sally O'Reilly, Goran Petrovic, Lorenza Pignatti, Matteo Rosa, David Rych, Michael Takeo Magruder, Tamar Tambeck, Barry Wickenden.

Finally, thanks to: Sam King, May Yao and Masoud Yazdani of Intellect Books for believing in the project; Morten Goll, who helped a great deal with the first draft; Sally O'Reilly (again) and Irit Rogoff, whose sharp minds (and pens) gave a start and an end to the book; and lastly to Andrei Siclodi, for giving me the opportunity to research full-time, and for the many conversations and thorough support in the last few years. Thank you again to all.

Bibliography

I am in debt no less to the following: (the list is long)

Note: whenever I could find it, I provided both a printed and an online source.
Agamben, Giorgio (2000), *Remnants of Auschwitz: The Witness and the Archive* (trans. Daniel Heller-Roazen), New York: Zone Books.
Andrews, Max (2006), 'A picture of war is not war', in *Frieze*, Issue 99, May, http://www.frieze. com/issue/print_back/a_picture_of_war_is_not_war/. Accessed 14 June 2009.
Arntsen, Hilde (2004), 'Comments on Stefan Jonsson's presentation', in Carlsson, Ulla, ed., *Nordicom Review 1-2/2004*, Special Issue: *The 16th Nordic Conference on Media and Communication Research*, pp. 69–73, http://www.nordicom.gu.se/eng.php?portal=publ&main= info_publ2.php&ex=134&me=7. Accessed 1 January 2007.
Art & Education (2008), *What is Real? Photography and the Politics of Truth*, press release, 12/09/08, http://www.artandeducation.net/announcements/view/586 and http://www.lightstalkers.org/ symposium-what-is-real-photography-and-the-politics-of-truth. Both accessed 13 June 2009.
Aucoin, James L. (2001), 'Epistemic responsibility and narrative theory: The literary journalism of Ryszard Kapuscinski', in *Journalism*, Vol. 2 (1), pp. 5–21, London, Thousand Oaks and New Delhi: Sage Publications, http://jou.sagepub.com/cgi/content/abstract/2/1/3. Accessed 24 November 2007.

Aufderheide, P. (2000) *The Daily Planet: A Critic on the Capitalist Culture Beat,* Minneapolis: University of Minnesota Press.

Bal, Mieke (2003), 'Visual essentialism and the object of visual culture', in *Journal of Visual Culture,* Vol. 2 (1), pp. 5–32, London, Thousand Oaks and New Delhi: Sage Publications.

Bangma, Anke, ed. (2005), *Looking, Encountering, Staging,* Rotterdam: Piet Zwart Institute, and Frankfurt a/M: Revolver.

Barthes, Roland (1977), *Image/Music/Text* (trans. Stephen Heath), New York: Noonda.

Barthes, Roland (1981), *Camera Lucida: Reflections on Photography* (trans. Richard Howard), New York: Hill and Wang. First published in French as *La Chambre Clair,* Editions du Seuil, 1980.

Beausse, Pascal (2000), 'Bruno Serralongue', in *Art Press,* 259, December (trans. L. S. Torgoff), http://doc.airdeparis.com/index.php?subdir=press/SERRALONGUE%20Bruno/. Accessed 27 March 2008.

Becker, Karin (2004): 'Where is visual culture in contemporary theories of media and communication?', in Carlsson, Ulla, ed., *Nordicom Review 1-2/2004, Special Issue: The 16th Nordic Conference on Media and Communication Research,* pp. 149–157, http://www.nordicom.gu.se/eng.php?portal=publ&main=info_publ2.php&ex=157&me=2. Accessed 11 November 2007.

Benjamin, Walter (1978), 'The author as producer', in Demetz, Peter, ed., *Reflections: Essays, Aphorisms, Autobiographical Writing* pp. 220–238, (trans. Edmund Jephcott), New York: Schoken. First published New York: Harcourt Brace Jovanovich, 1978, www.situations.org.uk/_uploaded_pdfs/AuthorasProducer.pdf. Accessed 20 April 2008. The text was originally delivered in a lecture at the Institute for the Study of Fascism in Paris on 27 April 1934, and then published in *New Left Review* I/62, July–August 1970.

Bensman, Joseph and Lilienfeld, Robert (1969), 'Phenomenology of journalism', in *Diogenes,* pp. 98–119, London, Thousand Oaks, CA and New Delhi: Sage Publications on behalf of the International Council for Philosophy and Humanistic Studies, http://dio.sagepub.com. Accessed 24 November 2007.

Berger, John (1972), *Ways of Seeing,* Harmondsworth: Penguin.

Bhimji, Zarina (2002), *Out of Blue,* online project description, http://www.zarinabhimji.com/dspseries/12/1FW.htm. Accessed 23 April 2009.

Boeri, Stefano, et al. (2003), 'Border syndrome. Notes for a research program', in Biesenbach, Klaus, ed., *Territories: Islands, Camps and Other States of Utopia* exhibition catalogue, pp. 52–60, Berlin and Cologne: KW Institute for Contemporary Art and Verlag der Buchhandlung Walther König.

Boon, Tim (2003–2008), 'Shipyard', in Bfi-British Film Institute Screenonline, http://www.screen online.org.uk/film/id/560369/index.html. Accessed 25 April 2009.

Bruno, Edoardo (2006), 'Cinema come filosofia', contribution to the Philosophy Festival in Rome, in *MicroMega* Nr. 7/2006: *Almanacco del Cinema Italiano,* pp. 93–116.

Casolari, Pierluigi (2007), 'Dirigo Io', in *D of la Repubblica,* Nr. 568, 6 October, p. 250, http://dweb.repubblica.it/dweb/2007/10/06/attualita/dspie/250med568250.html and http://periodici.repubblica.it/d/?num=568 (Italian only). Both accessed 23 June 2009.

Catlin, Stanton L. (1989), 'Traveller-reporter artists and the empirical tradition in post-independence Latin American art', in Ades, Dawn, ed., *Art in Latin America: The Modern Era, 1820–1980,* pp. 41–61, New Haven and London: Yale University Press.

Clifford, James (1988), *The Predicament of Culture: Twentieth Century Ethnography, Literature and Art,* Cambridge, Mass.: Harvard University Press.

Colard, Jean-Max (2002), 'Bruno Serralongue', in *Artforum International*, Vol. 40 (9), May, p. 190, http://www.findarticles.com/p/articles/mi_m0268/is_9_40/ai_86647208. Accessed 18 March 2008.

Colombo, Furio (2006), 'Il potere dell'informazione o l'informazione del potere?', in Ranieri Polese, ed., *Almanacco Guanda, Come si cambia. 1989-2006: la metamorfosi italiana*, pp. 65–81, Parma: Guanda.

Comcast Spotlight Corporate (n.d.), *VOD Advertising*, http://www.comcastspotlight.com/sites/Default.aspx?pageid=7608&siteid=62&subnav=3. Accessed 12 July 2008.

Cottle, Simon and Rai, Mugdha (2006), 'Between display and deliberation: Analysing TV news as communicative architecture', in *Media, Culture & Society*, 28, pp. 163–189, London, Thousand Oaks and New Delhi: Sage Publications, http://mcs.sagepub.com/cgi/content/abstract/28/2/163. Accessed 24 November 2007.

Crow, Thomas E. (2005), *The Rise of the Sixties: American and European Art in the Era of Dissent 1955-69*, London: Laurence King Publishing (first published London: Weidenfeld & Nicolson, 1996).

David, Catherine (2005), 'Everyone in his place?', in David, Catherine, ed., *One Step Beyond – Wiederbegegnung mit der Mine*, pp. 52–54, Ostfildern-Ruiz: Hatje Cantz Verlag.

Demos, T.J. (2006b), 'Life Full of Wholes', in *Grey Room*, no. 24, Fall 2006, pp. 72–88. Reprinted 2008 in Lind, Maria and Steyerl, Hito, eds., *The Greenroom – Reconsidering the Documentary and Contemporary Art*, Vol. 24, Fall, New York: Sternberg Press and Center for Curatorial Studies, Bard College.

Demos, T.J. (2008), 'Image Wars', in *Zones of Conflict* exhibition catalogue, pp. 3–10, New York: Pratt Manhattan Gallery.

Derrida, Jacques (1982), 'Signature, event, context', in *Margins of Philosophy* (trans. Alan Bass), pp. 307–330, Chicago: University of Chicago Press. First published 1971.

Eco, Umberto (1979), 'The poetics of the open work', in *The Role of the Reader: Explorations in the Semiotics of Texts*, pp. 47–66, Bloomington: Indiana University Press. First published in Italian as *Opera Aperta*, Milano: Bompiani, 1962.

Einsele, Lukas (2005), Introductory notes in David, Catherine, ed, *One Step Beyond – Wiederbegegnung mit der Mine*, pp. 4–5, Ostfildern-Ruiz: Hatje Cantz Verlag.

Eitzen, Dirk (1995), 'When is a documentary? Documentary as a mode of reception', in *Cinema Journal*, vol.35 (1), pp. 81–102.

Ekström, Mats (2002), 'Epistemologies of TV journalism: A theoretical framework', in *Journalism* Vol. 3 (3), pp. 259–282, London, Thousand Oaks, CA and New Delhi: Sage Publications, http://jou.sagepub.com/cgi/content/abstract/3/3/259. Accessed 24 November 2007.

Enwezor, Okwui (2003a), 'Documentary/verité: Biopolitics, human rights and the figure of truth', in *Australian and New Zealand Journal of Arts*, 5(1), pp. 11–42. See also a lecture by Enwezor, 'Documentary/verité: Photography, film, video, documentation, or, the figure of truth in contemporary art', presented at the Sterling and Francine Clark Art Institute in the symposium *American Art Now: Aesthetics and Politics*, 18 October 2003.

Enwezor, Okwui (2003b), 'Mega-exhibitions and the antinomies of a transnational global form', in *MJ – Manifesta Journal*, 2, Winter 2003/Spring 2004, pp. 6–31, Amsterdam: Manifesta Foundation.

Enwezor, Okwui (2004), 'Documentary/verité: The figure of "truth" in contemporary art', in Nash, Mark, ed., *Experiments with Truth* exhibition catalogue, Philadelphia: The Fabric Workshop and Museum.

Flusser, Vilém (2000), *Towards a Philosophy of Photography*, London: Reaktion Books (first edition published in Germany, 1983), http://korotonomedya2.googlepages.com/VilemFlusser-Towards APhilosophyofPho.pdf. Accessed 27 March 2008.

Foster, Hal (1996), 'The Artist as Ethnographer', in *The Return of the Real: The Avant-Garde at the End of the Century*, pp. 171–204, Cambridge, Mass.: MIT Press, Massachusetts Institute of Technology.

Foucault, Michel (1994 [1974]), 'Prisons et asiles dans le mécanisme du pouvoir', in *Dits et Ecrits*, t. II, pp. 523–524, Paris: Gallimard.

Foucault, Michel (1980), 'Truth and power', in Gordon, Colin, ed., *Power/Knowledge: Selected Interviews and other Writings, 1972–1977*, pp. 109–133, New York: Pantheon Books.

Foucault, Michel (1988), 'The art of telling the truth' in Kritzman, Lawrence, ed., *Michel Foucault: Politics, Philosophy, Culture, Interviews and Other Writings 1977–1984* (trans. A. Sheridan et. al.), pp. 86–95, New York: Routledge.

Fürsich, Elfriede (2002), 'How can global journalists represent the "Other"?: A critical assessment of the cultural studies concept for media practice', in *Journalism* Vol. 3 (1), pp. 57–84, London, Thousand Oaks, CA and New Delhi: Sage Publications, http://jou.sagepub.com/cgi/content/abstract/3/1/57. Accessed 24 November 2007.

Galbraith, John Kenneth (1998), *The Affluent Society*, Boston: Mariner Books/Houghton Mifflin Company. First published 1958.

Geertz, Clifford (2002), *The Interpretation of Cultures*, New York: Basic Books. First published 1973.

Gheorghe, Catalin (2007), 'Art as experimental journalism', post-factum contribution to the forum *SUMMIT non-aligned initiatives in education culture*, Berlin, 24–28 May 2007, http://summit. kein.org/wiki/Citizen_ka. Accessed 23 June 2009. Text published as a contribution for 'What is to be done (in art education)?', dossier in *Vector – Art and Culture in Context*, 4, presented at Documenta 12, 2007.

Gludovatz, Karin (2003), 'Grauwerte: Ein projekt von Klub Zwei zum gebrauch historischer dokumentarfotografie', in *Texte zur Kunst*, Nr. 51: *Nichts als die Warheit*, pp. 58–66.

Gould, Stephen J. (1991), 'Exaptation: A crucial tool for evolutionary psychology', in *Journal of Social Issues*, Vol. 47, pp. 43–65.

Gramuglio, Maria Teresa and Rosa, Nicolas (1999), 'Tucumàns Burns', in Alberro, Alexander and Stimson, Blake, eds., *Conceptual Art: A Critical Anthology*, pp. 360–365, Cambridge, Mass.: MIT Press. First published in Spanish by the General Confederation of Labor of the Argentineans in Rosario, Argentina, 1968.

Green, Renée (2001), 'Conversation between Renée Green, Lynne Tillman, and Joe Wood', in Rhomber, Kathrin, ed., *Between and Including* exhibition catalogue (trans. Frank-Großebner, Elisabeth), pp. 127–143, Vienna: Secession and Cologne: Dumont Buchverlag.

Grierson, John (1996), 'First principles of documentary', in Macdonald, Kevin and Cousins, Mark, eds., *Imagining Reality: The Faber Book of Documentary*, pp. 97–102, London: Faber and Faber.

Guerra, Carles (2006), 'The extraphotographic' (original title *L'extra-photographique*), in *Notre Historie* exhibition catalogue, pp. 191–195, Paris: Palais de Tokyo/Paris musées.

H.arta (Maria Crista, Anca Gyemant and Rodica Tache), (2006), 'About art and the ways we look at the world', in Babias, Marius and Nollert, Angelika, eds., *Periferic 7: Focussing Iasi/Social Processes* exhibition catalogue, pp. 100–185, Frankfurt a.M.: Revolver and Iasi: Editora Polirom.

Havránek, Vít; Schaschl-Cooper, Sabine; Steinbrügge, Bettina, eds. (2005a), *The Need to Document* exhibition catalogue, pp. 11–12, Zurich: JRP Ringier with the Kunsthaus Baselland, Basel, the Halle für Neue Kunst, Lüneburg, and tranzit, Prague.

Havránek, Vít (2005b), 'The documentary – An ontology of forms in transforming countries', in Havránek, Vít; Schaschl-Cooper, Sabine; Steinbrügge, Bettina, eds., *The Need to Document* exhibition catalogue, pp. 35–47, Zurich: JRP Ringier with the Kunsthaus Baselland, Basel, the Halle für Neue Kunst, Lüneburg, and tranzit, Prague.

Helstrup, Anjee (2003), 'Homeland insecurities: Diaspora and the public sphere', Master thesis at California College of the Arts, http://sites.cca.edu/currents/2003/ahelstrup_thesis.html. Accessed 18 January 2008.

Heritage, J. and Greatbatch, D. (1991), 'On the institutional character of institutional talk: The case of news interviews', in Boden, D. and Zimmerman, D.H., eds., *Talk and Social Structure*, pp. 93–137, Cambridge: Polity Press.

Holman, Jamie (2009), 'Still life in real time', in *The Saatchi Gallery Magazine Art & Music*, Issue 5, Spring, pp. 28–31, London: Art & Music Publications, http://www.saatchi-gallery.co.uk/artandmusic/?cid=315&from_cid=150. Accessed 21 April 2009.

Horelli, Laura (2005), 'Personal stories addressing structures in society', interview by Marius Babias, in Fabricius, Jacob, ed., *Interviews, Diaries and Reports*, pp. 79–83, Copenhagen: Pork Salad Press.

Huberman, Anthony (2007), 'I {don't love} Information', in *Afterall Magazine*, 16, Autumn/Winter, pp. 19–26. This article draws on the ideas of Roger M. Bruegel and Ruth Noack, who acted as curators of Documenta 12 (2007).

Huxford, John (2001), 'Beyond the referential: Uses of visual symbolism in the press', in *Journalism* Vol. 2 (1), pp. 45–71, London, Thousand Oaks and New Delhi: Sage Publications, http://jou. sagepub.com/cgi/content/abstract/2/1/45. Accessed 24 November 2007.

Jaar, Alfredo (1997), presentation at *Public Art 3: La Generazione delle Immagini*, a series of conferences and talks organized by the Municipality of Milano and curated by M. Senaldi and R. Pinto, 1996–1997, http://www.undo.net/cgi-bin/openframe.pl?x=/Pinto/Eng/fjarr.htm. Accessed 8 February 2008.

Jaar, Alfredo (1998), *Let There be Light: The Rwanda Project, 1994–1998*, Barcelona: Actar.

Jaar, Alfredo (2007), interview in *Art:21 – Art in the Twenty-First Century,* a US television series on contemporary visual art, PBS media enterprise, http://www.pbs.org/art21/artists/jaar/clip1.htm. Accessed 25 August 2008. Excerpts of video interviews and short texts by Jaar are available at http://www.pbs.org/art21/artists/jaar/index.html#. Accessed 23 April 2009.

James, Sarah (2008), 'Making an ugly world beautiful? Morality and aesthetics in the aftermath', in *Memory of Fire: the War of Images and Images of War,* pp. 12–15, programme brochure co-published by *Photoworks* and *BPB* on the occasion of the third Brighton Photo Biennial 3 October–16 November 2008.

Jameson, Fredric (1991), *Postmodernism: Or, the Cultural Logic of Late Capitalism*, Durham: Duke University Press.

Jameson, Fredric (2005), 'Foreword: A monument to radical instants', in Weiss, Peter, ed., *The Aesthetics of Resistance, Vol.1: A Novel* (trans. Joachim Neugroschel), pp. xii–xlix, Durham and London: Duke University Press. Reprinted 2007 in *The Modernist Papers*, pp. 380–419, London: Verso.

Jonsson, Stefan (2004), 'Facts of aesthetics and fictions of journalism: The logic of the media in the age of globalization' in Carlsson, Ulla, ed. (trans. Charly Hultén), *Nordicom Review 1-2/2004,* Special Issue: *The 16th Nordic Conference on Media and Communication Research,* pp. 57–68. Paper for the 16th Nordic Conference on Media and Communication Research, http://www.nordicom.gu.se/common/publ_pdf/157_057-068.pdf. Accessed 11 November 2007. Reprinted

2008 in Lind, Maria and Steyerl, Hito, eds., *The Greenroom – Reconsidering the Documentary and Contemporary Art*, Vol. 24, Fall, New York: Sternberg Press and Center for Curatorial Studies, Bard College.

Julien, Isaac and Nash, Mark (2000), 'Frantz Fanon as film', in *The Film Art of Isaac Julien*, pp. 103–110, Annandale-on-Hudson, NY: Center for Curatorial Studies, Bard College. Published also in *NKA: Journal of Contemporary African Art*, No. 11/12, Fall/Winter 2000; in Anglistica, Vol. 4 (2), 2000; and as 'Frantz Fanon – Kritische Genealogien' (trans. Ute Meta Bauer), http://www.haussite.net/haus.0/SCRIPT/txt2000/04/fanweb.HTML. Accessed 23 June 2009. Text first presented as a paper at the conference *Between Colonialism: Frontiers of the Body/Frontiers of Identity*, Istituto Universitario Orientale, Naples, Italy, May 1998.

Kak, Sanjay (2004), 'Politics in the picture: Witnessing environmental crises in the media', in Sengupta, Shuddhabrata; Narula, Monica; Vasudevan, Ravi; Sundaram, Ravi; Bagchi, Jeebesh; Sharan, Awadhendra [Sarai] and Lovink, Geert, eds., *Sarai Reader 04: Crisis/Media*, pp. 325–329, New Delhi: Centre for the Study of Developing Society, http://www.sarai.net/publications/readers/04-crisis-media/04-crisis-media. Accessed 28 December 2007.

Kortun, Vasif and Esche, Charles (2005), *The World Can Be Transformed by Action*, e-mail interview by Minna Henriksson with the curators of the 9th Istanbul Biennial, 16th September–30th October 2005, handout available at the time of the exhibition.

Krauss, Rosalind (2006), 'Two moments from the post-medium condition', in *October*, Vol. 116, Spring, pp. 55–62.

Krauss, Rosalind (2007), 'Truth the encounter: Ten (true) stories', in *Texte zur Kunst*, Nr. 66, pp. 131–134 (English part: 133–134).

Kvale, Steinar (1995), 'Themes of postmodernity', in Anderson, W.T., ed., *The Truth About the Truth: De-confusing and Reconstructing the Postmodern World*, pp. 18–25, New York: Putnam.

Lafuente, Pablo (2007), Art and the foreigner's gaze: a report on Contemporary Arab Representations, in *Afterall*, Issue 15, Spring-Summer, pp. 13–23.

Latour, Bruno (1987), *Science in Action: How to Follow Scientists and Engineers through Society*, Cambridge, Mass.: Harvard University Press.

Lewison, Jeremy; Ridley, Anna; Hammond, Paul and Lubbock, Tom (2007), *The Work of Ian Breakwell (1943–2005)*, conference held at Tate Britain, London, on 12 May 2007, http://www.tate.org.uk/onlineevents/podcast/. Accessed 14 May 2008.

Lovink, Geert (2004), 'Guerrilla news network's digital documentaries. Interview with Stephen Marshall', in Sengupta, Shuddhabrata; Narula, Monica; Vasudevan, Ravi; Sundaram, Ravi; Bagchi, Jeebesh; Sharan, Awadhendra [Sarai] and Lovink, Geert, eds., *Sarai Reader 04: Crisis/Media*, pp. 294–302, New Delhi: Centre for the Study of Developing Society, http://www.sarai.net/publications/readers/04-crisis-media/04-crisis-media. Accessed 22 June 2009.

Lovink, Geert (2008), 'The society of the query and the Googlization of our lives. A tribute to Joseph Weizenbaum', in *Eurozine Newsletter*, 10/2008, http://www.eurozine.com/articles/2008-09-05-lovink-en.html. Accessed 4 October 2008. First published in *Lettre International*, 81 (German version).

Marra, Claudio (2005), 'Fotografia come arte', in Poli, Francesco, ed., *Arte contemporanea: le ricerche internazionali dalla fine degli anni '50 ad oggi*, pp. 248–273, Milano: Mondadori Electa. First published 2003.

Martens, Renzo (2005), presentation of his work for *On Documenting (truth and politics)* at BAK, basis voor actuele kunst in Utrecht, 12 November 2005, http://www.bak-utrecht.nl/videos/

2005/ConcerningWar/OnDocumenting/OnDocumenting1RMartens.html. Accessed 6 February 2008.

Martens, Renzo (2009), discussion with J.J. Charlesworth of *Art Review* on the occasion of Martens's exhibition *Episode III – Enjoy* at London's Wilkinson Gallery, 16 January–22 February 2009, http://www.artreview.com/video/video/show?id=1474022%3AVideo%3A714260 (part I); http://www.artreview.com/video/video/show?id=1474022%3AVideo%3A714365 (part II). Both accessed 21 April 2009.

McLuhan, Marshall (1994), *Understanding Media: The Extensions of Man* (intr. Lewis H. Lapham), Cambridge, Mass.: MIT Press. First published by Mentor, New York, 1964.

Meyer, James (2002), 'Tunnel Visions', in Higgs, Matthew; Holert, Tom; Meyer, James and Nochlin, Linda, 'Platform muse: Documenta 11', in *Artforum International*, vol. 41 (1), September, pp. 168–169, http://findarticles.com/p/articles/mi_m0268/is_1_41/ai_91202134/. Accessed 11 June 2009.

Montani, Pietro (2007), *Bioestetica. Senso comune, tecnica e arte nell'età della globalizzazione*, Roma: Carocci Editore.

Multiplicity (2003), 'Frequently asked questions', in *Uncertain States of Europe*, pp. 14–27, Milan: Skira Editore.

Murdoch, Rupert (2005), *My Media Vision*, speech at the American Society of Newspaper Editors, 13 April 2005, http://www.newscorp.com/news/news_247.html and http://www.independent.co.uk/news/media/murdoch-my-media-vision-489669.html. Both accessed 12 June 2009.

Nash, Mark (2008), 'Reality in the age of aesthetics', in *Frieze*, Issue 114, April, pp. 118–125, http://www.frieze.com/issue/print_article/reality_in_the_age_of_aesthetics. Accessed 5 August 2008.

Natharius, David (2004), 'The more we know, the more we see: The role of visuality in media literacy', in *American Behavioral Scientist*, 48 (2), pp. 238–247, London, Thousand Oaks and New Delhi: Sage Publications, http://abs.sagepub.com/cgi/content/abstract/48/2/238. Accessed 27 November 2007.

Neubauer, Susanne, ed. (2005), *Documentary Creations* (exhibition catalogue), Frankfurt a.M.: Revolver with Kunstmuseum Luzern.

Nichols, Bill (1997), *Representing Reality. Issues and Concepts in Documentary*, Bloomington and Indianapolis: Indiana University Press. First published 1991.

Nichols, Bill (2001), 'Documentary film and the modernist avant-garde', in *Critical Enquiry*, 27 (4), Summer, pp. 580–610.

Nolte, Paul (2004), 'Lift the fog!', in *Bundeskulturstiftung Magazine*, 3, pp. 3–5 (English version), Halle and der Saale: Kulturstiftung des Bundes (German Cultural Foundation).

Ogilvie, Bertrand (2005), 'A targetless crime?', in David, Catherine, ed., *One Step Beyond – Wiederbegegnung mit der Mine*, pp. 184–190, Ostfildern-Ruiz: Hatje Cantz Verlag.

Raad, Walid (2005), 'Hostage: The Bachar tapes', in Ardi, Yunanto; Che, Kyongfa; Agung, Hujatnikajenong and Ade, Darmawan, eds., *ok video 2005* exhibition catalogue, p. 28, Jakarta: Ruangrupa. For The Atlas Group archive, http://www.theatlasgroup.org. Accessed 15 June 2009.

Raad, Walid (2006), '"Oh God," he said, talking to a tree: a fresh-off-the-boat, throat-cleaning preamble about the recent events in Lebanon. And a question to Walid Sadek', in *Artforum International*, October, Vol. 45 (2), pp. 242–244.

Raad, Walid and Toufic, Jalal (2007), *The Withdrawal of Tradition Past a Surpassing Disaster*, video of opening lecture Seminar 3 of the artistic project UNP (UnitedNationsPlaza) on 31 January

2007, Platz der Vereinten Nationen, Berlin, http://unp.kein.org/node/213. Accessed 15 November 2008. The seminar series took place from 31 January 2007 to 12 February 2007.

Rancière, Jacques (2003), *Short Voyages to the Land of the People* (trans. James B. Swenson), Palo Alto, CA: Stanford University Press.

Rancière, Jacques (2006a), 'Some paradoxes of political art', lecture at the conference *Home Works III* in Beirut., 17–24 November.

Rancière, Jacques (2006b), 'Documentary fiction: Marker and the fiction of memory' (trans. Emiliano Battista) in *Film Fables*, p. 158, New York: Berg, 2006.

Rancière, Jacques (2007a), 'The emancipated spectator', in *Artforum International*, vol. 45 (7), March, pp. 271–280. Text for a lecture originally presented in 2004 at the opening of the 5th Summer Academy of Arts in Frankfurt a/M (Germany), and then published in *Texte zur Kunst*, Nr. 58, June 2005, pp. 35–51.

Rancière, Jacques (2007b), 'Art of the possible', interview with Fulvia Carnevale and John Kelsey in *Artforum International*, vol. 45 (7), March, pp. 256–269.

Raunig, Gerald (2005), 'The document as present becoming', in Havránek, Vít; Schaschl-Cooper, Sabine and Steinbrügge, Bettina, eds., *The Need to Document* exhibition catalogue, pp. 89–98, Zurich: JRP Ringier with the Kunsthaus Baselland, Basel, the Halle für Neue Kunst, Lüneburg, and tranzit, Prague.

Rehberg, Vivian (2005), 'The Documentary Impulse', in *Jong Holland*, issue 4 (21): *documentair*, http://www.jong-holland.nl/4-2005/rehberg.htm. Accessed 22 June 2009.

Rehm, Jean-Pierre (2005), 'Documentary heresy', in Kunstmuseum Luzern, ed., *Documentary Creations* exhibition catalogue, pp. 43–47, Frankfurt a.M: Revolver.

Ricuperati, Gianluigi (2007), 'La mappa delle mine', book review in *D Magazine* of the newspaper *la Repubblica*, Nr. 532, January, p.25, http://dweb.repubblica.it/dweb/2007/01/20/attualita/attualita/024mos53224.html# and http://periodici.repubblica.it/d/?num=532 (Italian only). Both accessed 17 June 2009.

Ridley, Anna (2008), 'Art on Channel 4', email to the curators in the programme notes of *Broadcast Yourself*, exhibition at Cornerhouse, Manchester, 13 June–10 August 2008, n.p.

Rifkin, Jeremy (2000), *The Age of Access: The New Culture of Hypercapitalism, Where All of Life is a Paid-For Experience*, New York: J.P. Tarcher/Putnam Publishing Group.

Roberts, John (1998), *The Art of Interruptions: Realism, Photography and the Everyday*, Manchester and New York: Manchester University Press.

Robinson, Piers; Brown, Robin; Goddard, Peter and Parry, Katy (2005), 'War and media', in *Media, Culture & Society*, 27, pp. 951–959, London, Thousand Oaks and New Delhi: Sage Publications, http://mcs.sagepub.com. Accessed 27 November 2007.

Roelandt, Els (2008), 'Renzo Martens' Episode 3: Analysis of a film process in three conversations', in *A Prior Magazine*, 16, February, http://www.aprior.org/n16_content.htm, and http://squarevzw.be/picturethis/renzoapm16.htm. Both accessed 15 February 2008. See also http://www.aprior.org/articles/34. Accessed 23 June 2009.

Rogoff, Irit (2002), 'WE. Collectivities, Mutualities, Participations', in *I Promise it's Political: Performativity in Art* exhibition catalogue, pp. 126–34, Cologne: Theater der Welt and Museum Ludwig. Text presented at *Klartext! The Status of the Political in Contemporary Art and Culture* conference in Berlin, 14 January 2005, http://theater.kein.org/node/95. Accessed 14 June 2009.

Rogoff, Irit (2007), *Academy as Potentiality*, http://summit.kein.org/node/191. Accessed 21 October 2008.

Rosler, Martha (1993), 'In, around, and afterthoughts: On documentary photography', in *The Contest of Meaning: Critical Histories of Photography*, Richard Bolton, ed., 4th Edition, pp. 303–342: Cambridge, Mass.: MIT Press. First published in *3 Works*, Halifax, N.S.: Press of the Nova Scotia College of Art & Design, 1981.

Rotha, Paul with Road, Sinclair and Griffith, Richard (1952), *Documentary film: the use of the film medium to interpret creatively and in social terms the life of the people as it exists in reality*, London: Faber.

Saxton, Libby (2003), 'Anamnesis Godard / Lanzmann', in *Trafic* n° 47, Autumn, pp. 48–66. Reprinted as 'Anamnesis and Bearing Witness', in Temple, Michael; Williams, James S. and Witt, Michael, eds., *For Ever Godard: The Work of Jean-Luc Godard 1950–2000*, pp. 364–379, London: Black Dog Publishing, 2004.

Scanlan, Joe (1995), 'Alfredo Jaar', in *Frieze*, Issue 22, May, http://www.frieze.com/issue/review/alfredo_jaar/. Accessed 9 February 2008.

Scannell, Paddy (1996), *Radio, Television and Modern Life*, Oxford: Blackwell.

Schiller, Herbert I. (1989), *Culture Inc*, Oxford: Oxford University Press, http://www.source watch.org/index.php?title=Push_poll. Accessed 9 January 2008.

Schober, Anna (2009), *Ironie, Montage, Verfremdung. Ästhetische Taktiken und die politische Gestalt der Demokratie*, Munich: Wilhelm Fink Verlag. An English version of the text is printed as 'Irony, montage, alienation. Aesthetic tactics and the invention of an avant-garde tradition', in *Afterimage. The journal of media arts and cultural criticism*, November 2009 (forthcoming at the time of printing).

Schudson, Michael (1995), *The Power of News*, London: Harvard University Press.

Sekula, Allan (1999), 'Documentary and corporate violence', in Alberro, Alexander and Stimson, Blake, eds., *Conceptual Art: A Critical Anthology*, pp. 360–365, Cambridge, Mass.: MIT Press. First published as 'Dismantling modernism, reinventing documentary (notes on the politics of representation)', in *Massachusetts Review*, Summer 1978, and then in Harrison, Helen M.; David, Anton; Antin, Eleanor; Harrison, Newton; Lonidier, Fred; Straser, Barbara et al., *Dialogue-Discourse-Research* exhibition catalogue, Santa Barbara Museum of Art, 1979.

Sheikh, Simon (2006), 'Spaces or Thinking: Perspectives on the Art Academy', in *Texte zur Kunst*, Nr. 62, June, pp. 191–196, http://backissues.textezurkunst.de/NR62/SIMON-SHEIKH_en.html. Accessed 22 June 2009.

Siemens AG (2008, n.d.), The Siemens Arts Program, https://www.siemensartsprogram.de/konzept.php. Accessed 27 July 2008.

Silverman, Kaja (1996), *The Threshold of the Visible World*, New York and London: Routledge.

Simmel, Georg (1964 [1950]), 'Part Three: Superordination and subordination, Leader and Led', in *The Sociology of Georg Rimmel* (trans. Kurt H. Wolff), pp. 185–186, Glencoe, Illinois: The Free Press, http://www.scienzepostmoderne.org/Libri/SociologyOfGeorgSimmel.html. Accessed 24 June 2009.

Smith, Sidney (2009), 'Camera Obscura', in Frieze, Issue 121, March, pp. 138–141, http://www.frieze.com/issue/print_article/camera_obscura/. Accessed 22 June 2009.

Sontag, Susan (1977), *On Photography*, London: Penguin. First published in New York: Farrar, Straus and Giroux, 1973.

Sontag, Susan (2003), *Regarding the Pain of Others*, New York: Farrar, Straus and Giroux.

Spinelli, Claudia, ed. (2005), *Reprocessing Reality* exhibition catalogue, Zurich: JRP Ringier.

Stallabrass, Julian (2008), 'The power and impotence of images', in *Memory of Fire: the War of Images and Images of War* (London and Brighton: Photoworks and BPB Brighton Photo

Biennial), p. 8. Published on the occasion of the third Brighton Photo Biennial 3 October–16 November 2008.

Stephens, M. (1988), *A History of News*, New York: Viking Press.

Steyerl, Hito (2003), *Documentarism as Politics of Truth*, http://www.republicart.net/disc/representations/steyerl03_en.pdf. Accessed 19 April 2008.

Steyerl, Hito (2005), 'Politics of the truth. Documentary in the field of art', in *The Need to Document* exhibition catalogue, pp. 57–63, Zurich: JRP Ringier.

Steyerl, Hito (2007), 'Documentary uncertainty', in *A Prior Magazine*, 15, http://www.aprior.org/n15_content.htm. Accessed 26 March 2008. Steyerl also gave lectures on the same topic at Künstlerhaus Büchsenhausen in Innsbruck on 7 March 2008, and at BAK in Utrecht, http://www.bak-utrecht.nl/videos/2005/ConcerningWar/OnDocumenting/OnDocumenting2HSteyerl.html. Accessed 19 April 2008.

Suchan, Jim (2004), 'Writing, authenticity, and knowledge creation: Why I write and you should too', in *Journal of Business Communication*, vol. 41 (3), pp. 302–315.

Swenson, Kirsten (2009), 'Be my mirror', in *Art in America*, 05 May 2009, http://www.artinamericamagazine.com/features/dan-graham-be-my-mirror-kirsten-swenson/. Accessed 13 June 2009.

Toppila, Paula (2006), 'Decoys, truths and video tapes', in *Interviews, Diaries and Reports,* pp. 53–59, Copenhagen: Pork Salad Press.

Toufic, Jalal (1996), *Over-Sensitivity*, Los Angeles: Sun and Moon Press.

Toufic, Jalal (2000), 'Forthcoming', in *Forthcoming*, pp. 46–75, Berkeley, CA: Atelos.

Tretyakov, Sergey; Shklovsky, Viktor; Shub Esfir and Brik, Osip (1971), 'Symposium on Soviet documentary', in Jacobs, Lewis, ed., *The Documentary Tradition: From Nanook to Woodstock*, pp. 29–36, New York: Hopkinson & Blake.

Vande Veire, Frank (2008), *Une bonne nouvelle: Notes on Episode III*, in SMBA Stedeijck Museum Bureau Amsterdam Newsletter no. 107, n. p., http://www.smba.nl/static/en/exhibitions/renzo-martens-episode-iii/107-nieuwsbrief-web-1-.pdf. Accessed 17 April 2009.

Vertov, Dziga (Denis Kaufman) (1984), *Kino-Eye: The Writing of Dziga Vertov,* Drobashenko, Sergie, ed. (trans. K. O'Brien), Berkeley: University of California Press.

Virilio, Paul (2004), *2 More Virilio Interviews – 07.20.04*, interview with James Der Derian (trans. J. Der Derian, M. Degener and L. Osepchuk), http://www.16beavergroup.org/mtarchive/archives/001128print.html. Accessed 20 April 2008.

Virilio, Paul, (2007), *L'arte dell'accecamento*, Milano: Raffaello Cortina Editore. First edition in French as *L'art à perte de vue*, Editions Galilée, 2005.

Vrba, Elizabeth S. and Gould, Stephen J. (1982), 'Exaptation – A missing term in the science of form', in *Paleobiology*, Vol. 8(1), Winter, pp. 4–15, http://links.jstor.org/sici?sici=0094-8373%28198224%298%3A1%3C4%3AEMTITS%3E2.0.CO%3B2-0. Accessed 22 June 2009.

Wall, Jeff (2007), 'Depiction, object, event', in *Afterall Magazine*, 16, Autumn/Winter, pp. 5–17. The text was originally produced for a public lecture held on 29 October 2006 in 's-Hertogenbosch, the Netherlands.

Wall, Melissa (2005), '"Blogs of war": "Weblogs as news"', in *Journalism*, 6, http://jou.sagepub.com/cgi/content/abstract/6/2/153. Accessed 3 August 2008.

Wallace, David Foster (2005), 'Host', in *Consider the Lobster and Other Essays*, pp. 275–345, New York: Little, Brown & Co.

Weizenbaum, Joseph (1976), *Computer Power and Human Reason*, San Francisco: W.H. Freeman & Company.

Weizenbaum, Joseph and Wendt, Gunna (2006), *Wo sind sie, die Inseln der Vernunft im Cyberstrom, Auswege aus der programmierten Gesellschaft*, Freiburg: Herder Verlag. (English trans: *Where are they, the islands of reason in the cyber sea? Ways out of the programmed society*).

Wickenden, Barry (2007), 'Latency: Ruins and image worlds in Beirut', unpublished paper BA Art History (International) dissertation at The University of Leeds, School of Fine Art, History and Cultural Studies.

Williams, Bruce A. and Delli Carpini, Michael X. (2000), 'Unchained reaction: The collapse of media gatekeeping and the Clinton-Lewinsky scandal', in *Journalism. Theory, Practice & Criticism*, 1(1), pp. 61–85, London, Thousand Oaks, CA and New Delhi: Sage Publications.

Wilson-Goldie, Kaelen (2005), 'Interview with Jalal Toufic', in Shiroma, Jerrold, ed., *Towards a Foreign Likeness Bent: Translation*, Sausalito, CA: Duration Press, pp. 91–96, http://www.durationpress.com/poetics/translation.htm. Accessed 15 June 2009.

Winston, Brian (1995), *Claiming the Real: The Griersonian Documentary and its Legitimations*, London: British Film Institute.

Wittgenstein, Ludwig (2001), *Philosophical Investigations* (trans. G.E.M. Anscombe), Oxford: Blackwell Publishing. First published 1953.

Wood, Michael R. and Zurcher, Louis A. (1988), *The Development of a Post Modern Self: A Computer-Assisted Comparative Analysis of Personal Documents*, Westport, CT: Greenwood Press.

Žižek, Slavoj (2002), 'The prospects of radical politics today', in Enwezor, Okwui; Basualdo, Carlos; Maharaj, Sarat et. al., eds., *Documenta 11_Platform 1, Democracy Unrealized*, pp. 67–85, Stuttgart: Hatje Kantz Verlag.

Žižek, Slavoj (2003–2004), 'Blows against the empire?', in *MJ – Manifesta Journal* no.2, pp. 40–49, Amsterdam: Manifesta Foundation, Winter/Spring.

Afterword

Bared Life

by Irit Rogoff

Our moment is characterised by an intriguing dilemma, one which positions the circulation of knowledge of a globalized world, somewhere between information, consumption and actualisation. The need to know, to arm ourselves with knowledge in order to navigate the scale of worldwide politics within twenty first century globalized economies; economies of knowledge production, economies of fear, economies of the mobile markets of labour, goods and capital, economies of cultural circulation, has made very clear its demands. Even more so the imposition of worldwide systems of rights and of wrongs, of inclusions and exclusions, of the efforts to produce universal indexes of measure that both reference the local and transcend it at the same time, have completely reframed our relation to the knowledge of other places.

My subject here today has to do with trying to understand these, as they have become instantiated in the 'documentary turn' – not as the consumption of information and cultural difference but as actualisation. As we in the art world have attempted to follow and understand the significance of the so called 'documentary turn' in both practice and display strategies, we have also understood that we cannot unravel why it has so compelled us, through discussions of 'documenting the truth', 'exposing reality' or 'countering official media'.

My thoughts have for some time been with Giorgio Agamben's *Homo Sacer* and with his conception of 'bare life', life which is stripped of every facet of human concern and protection, but has not yet entered the symbolic order of the sacrificed, of those whose death can sit comfortable within a juridical order. I would like to argue the temporal gap, the suspension of time, which is implicit in the notion of the *Homo Sacer*, 'that which is killed and not yet sacrificed', as the temporality of the documentary turn. No longer grounded in representation, it is the living out of this temporal gap between being and entering the symbolic order.

In thinking what circulates as documentary turn – which is after all a category of style, a category of assumed content – as a series of affects of our desire to know, of our relation to the experience of otherness, as an index of measure of the extent to which we 'are in the world', I think I am distancing its supposed immediacy, flattening out the thrill of having privileged insider knowledge, refusing the positivist assumption that if we confront enough facts, dig up enough information, we will actually have an informed understanding of the place, or of the event. In fact, of the outside trying to perform 'inside'.

Instead, the temporal gap I would like to privilege, that suspension of time between the event and the ability to grasp it, the ability to locate it within a grand narrative or a symbolic order, is infused by our drive to know and it is this drive which is served up for

us by the documentary turn. My 'bared life' condition is one of actualisation; by this Deleuze means the actualisation of the potential immanent to any component of the culture, not what is already there simply waiting to be excavated but that which will surely come into being. And what comes into being is our capacity to take it on board, to inhabit rather than to observe the implications of what we might be seeing, looking at.

Irit Rogoff

Note

The above is an extract from 'Bared Life' in *Unbounded – Limit's Possibilities*, Routledge, 2009.

The café is cosy, a bit too intellectual, perhaps. Anyway. We have the maps with us. Not that we took the pictures off the wall, or the DVDs out from the players; simply, we cannot (yet) let go what we've seen 'inside'. Inside: precisely what is a bit odd, the idea of inside and outside. Being here sipping lattes feels weird.

The exhibition catalogue is on the table, in its cellophane, still untouched. Will the maps inside correspond with those in our mind? It's not important, in the end. Perhaps the good thing is that, once left, we always reconstruct everything in the way we like. It doesn't matter what we've seen, but what we'll make out if it. (In theory.)

You put away the catalogue, in your green square bag. We'll have time for this, you say. The maps will mix together with today's news in the paper, last week's browsing of the internet and our school teacher's voice from when we were kids. I feel I need air. Or perhaps, I need to move from this place to another. In the end, we constantly move from A to B. Or are we staying where we are, and think we're moving?